DYNAMIC LIGHT AND SHADE

DYNAMIC LIGHT AND SHADE

BY BURNE HOGARTH

WATSON-GUPTILL PUBLICATIONS/NEW YORK

Artwork appearing on pages 67, 96, 114, 132, 133, 146, 152, 154, 155, and 156 is based on Edgar Rice Burroughs' *Jungle Tales of Tarzan* and is used courtesy of Edgar Rice Burroughs, Inc.

First published 1981 in the United States and Canada by Watson-Guptill Publications, a division of Billboard Publications, Inc., 1515 Broadway, New York, N.Y. 10036

Library of Congress Cataloging in Publication Data
Hogarth, Burne.
 Dynamic light and shade.
 Bibliography: p.
 Includes index.
 1. Shades and shadows. 2. Drawing—Technique.
I. Title.
NC755.H63 741.2 81-11390
ISBN 0-8230-1580-7 AACR2

Manufactured in U.S.A.

First Printing, 1981

1 2 3 4 5 6 7 8 9/86 85 84 83 82 81

Edited by Bonnie Silverstein
Designed by Bob Fillie and James Craig
Set in 9-point Palatino

It is with deep love I dedicate this book to my children, Ross, Richard, Michael, and his child, Stephanie; and also to Don Holden of Watson-Guptill for his intelligence, insight, and warmth, a human being in the best sense.

Acknowledgments

I wish to acknowledge the capable and generous assistance of James Craig, Virginia Croft, Bonnie Silverstein, and Don Holden (who was there from the very start), all from Watson-Guptill, for their direction and guidance in the details of design, editorial, promotional, and manufacturing needs of this book.

For photographic backup, I thank Yousef Habhab of Mastandrea Studios in Mount Kisco, NY, and Dan Demetriad, who both gave unstintingly of their time and expertise. Special mention is made to Jerry Robinson for use of his *Moon Trip* (Putnam) illustrations; to Don Ivan Punchatz for permission to use his American Hero painting; in memoriam, to Herbert Morton Stoops, for the illustrations of western life; to Kaethe Kollwitz, for the powerful, moving etching of the "Schlachtfeld"; and to the ukiyo-e masters, Hiroshige and Koryusai, for their striking and elegant woodcuts of Japanese landscapes.

Special acknowledgment is given to Marion Burroughs, Vice President, and Edgar Rich Burroughs, Inc., of Tarzana, CA, for their permission to publish illustrations created by the author: four panels from the newspaper syndicated Sunday page, *Tarzan* (Copyright 1947, 1949, 1950, Edgar Rice Burroughs, Inc., All Rights Reserved); and seven illustrations, appearing in Chapters 6, 8, 11, 13, and 15, based on the book by Edgar Rice Burroughs, *Jungle Tales of Tarzan* (Copyright 1976, Edgar Rice Burroughs, Inc., All Rights Reserved).

I also affirm an obligation and heartfelt thanks to those artists and printmakers, living and dead, before and after photography, who set forth in pictorial record the experiential events of the numerous problematical phenomena of light and shade which, in their totality, lie beyond the province of any one person to amass, know, or express.

CONTENTS

INTRODUCTION

We see the way our social order *lets* us perceive. To put it another way, our perceptions mirror or symbolize the behavior of a specific culture. It is through art that these perceptions are expressed; art sets forth the *visual* form of our social experience. Thus art is an expression of the perceived values of a socio-cultural process at a given time in history. The following story, which I read several years ago though I don't exactly recall where, illustrates this point.

In the eighteenth century, a British naval mission was dispatched to the Far East to open diplomatic relations and trade with China. To introduce his sovereign to the Chinese emperor, the British admiral presented a portrait of King George III painted in the grand style of the Baroque era. The painting was handsomely executed—a three-quarter view with dramatic chiaroscuro that plunged one side of the face into deep shadow.

The Chinese emperor perused the picture, pausing to study the dark tone on the shadow side of the face. Turning to the admiral, the emperor politely commented on the British king's disability. Was he, in fact, missing an eye, and was one side of his face so badly discolored? The admiral did his best to explain that his sovereign was in no way disabled, and that the portrait was an excellent likeness.

The Chinese emperor ordered his own portrait brought before them. Like the European painting, the Chinese portrait was skillfully done, but it was a frontal view, showing the features in bilateral symmetry, with flat color and no suggestion of light and shade. Pointing to the clear skin and the intact features, the emperor declared that the portrait was a perfect likeness of a sovereign in good health. "Why," he wondered, "is the king's portrait so dark and discolored if the British Lord is well?"

The portraits, in this apocryphal story, represent two irreconcilable viewpoints about painting—and specifically about the function of light. The difference is *not* in the paintings, but in social values—the way in which each society trains its members to *see*. What *we* know as light and shade, and the way in which our culture comprehends light and shade in a picture, is simply *our* way of seeing. Other societies do not always conceive or express light and shade as we do.

As Max Friedländer, art historian and author of *On Art and Connoisseurship*, has said: "The light that strikes the eye is not the same as the light that strikes the mind." In short, we see in the way that a social order trains us to perceive.

In our day, westerners like ourselves approach the universe with an empirical, analytical, scientific viewpoint, stemming from early Greek civilization, and rediscovered in the Renaissance with the birth of modern science. We are interested in art that describes deep space (through linear and atmospheric perspective), anatomical form, and the effects of time, seasons, and weather. Western artists and their audience are concerned with light that illuminates these specific phenomena in nature.

Thus, the purpose of this book is to show the objective, naturalistic properties of light and shade—the visual appearance of the world as modern western man is trained to perceive it. The book will also explore the expressive qualities of light and shade—the realm of mood, affect, and subjective phenomena.

We will begin with light and shade in their primary, most basic form: the concept of figure and ground—the silhouette as *form* on the white *ground* of the paper. Then we will examine a series of silhouette forms that imply spatial recession on the white ground. We will discuss reverse silhouettes and silhouettes of various sizes that create the illusion of space, near and far.

We will explore the ways in which minimal light (or highlight) reveals form, and we will see the effects of five fundamental categories of light and shade: single-source light; double-source light; flat, diffused light; moonlight; and sculptural light.

We will investigate spatial light—how values create space; environmental light—the effects of weather, atmosphere, time, and the seasons; textural light—the way in which light reveals surface qualities; transparent light—the effects of light on transparent, translucent, and reflective materials; fragmentation light—which conveys disintegration of form in motion; radiant light—the intense light of the sun or an artificial light source; and finally, expressive light—the psychological and poetic power of light.

These phenomena are illustrated with a wide range of drawing media: pencil, charcoal, carbon, pen-and-ink, brush-and-ink on a variety of drawing surfaces, ranging from conventional papers to exotic textures like linen. The reader is encouraged to experiment with diverse media as a means of researching the problems of light and shade—and a means of spurring the reader's awareness of the solutions.

BLACK-AND-WHITE SILHOUETTE

The Picture Plane as a Field of Light
When an artist sits before a sheet of white paper to make a drawing, he sees the picture plane—whether consciously or intuitively—as a field of light. In the same way, he sees any mark, stroke, or scribble within that picture plane as a form, a presence—something inside that field of light. In short, the bounded area of the paper has become a *place*, and the mark, no matter how crude, has become a *thing*.

Picture Plane
This rectangular area—which may be a sheet of drawing paper or a canvas—is a simple picture plane. If you think of this rectangle as a *space*, the picture plane becomes a void, a ground, a field of light that may contain some kind of mark that represents a form.

Figure and Ground
When this rectangular space is filled with a mark, a number, a triangle, a tree, there is now a presence in the void. We now have what psychologists call "figure and ground." The ground is the bare rectangle, while the figure is a mark that interrupts the void. If you can recognize a specific form in that bare rectangle—such as a tree—then you are convinced that a "thing" can be said to "exist" within that space. No amount of argument will dissuade you from knowing that you are seeing a figure in its ground or field of light, that you are seeing an image inside the picture frame. The idea leaps to your mind that *you are looking into a real space.*

The Silhouette as a Form in Space
Once we have accepted the white space as a field of light—a background on which things may happen—then *any form* that interrupts the field of light becomes something "real." It becomes a "figure" on a "ground." The simplest example of a figure on a ground is a silhouette on a piece of white paper. A silhouette is a profile view of an object, the simplest essence of a form in space, recognizable as a dimensional object within the field of light.

Geometrical Silhouettes
Some silhouettes are ambiguous and some are not. In the first column at the left, the three squares are ambiguous because they do not suggest specific three-dimensional forms. It is not clear whether they represent cubes, a head-on view of a cylinder, or the rectangular base of a pyramid. The middle column represents a slight shift in viewpoint, with less visual confusion: the three silhouettes do, in fact, suggest a cubic form, a cylinder, and a pyramid. But the three silhouettes in the right-hand column are clearer still, particularly in the case of the pyramid, which now obviously rests on a square base.

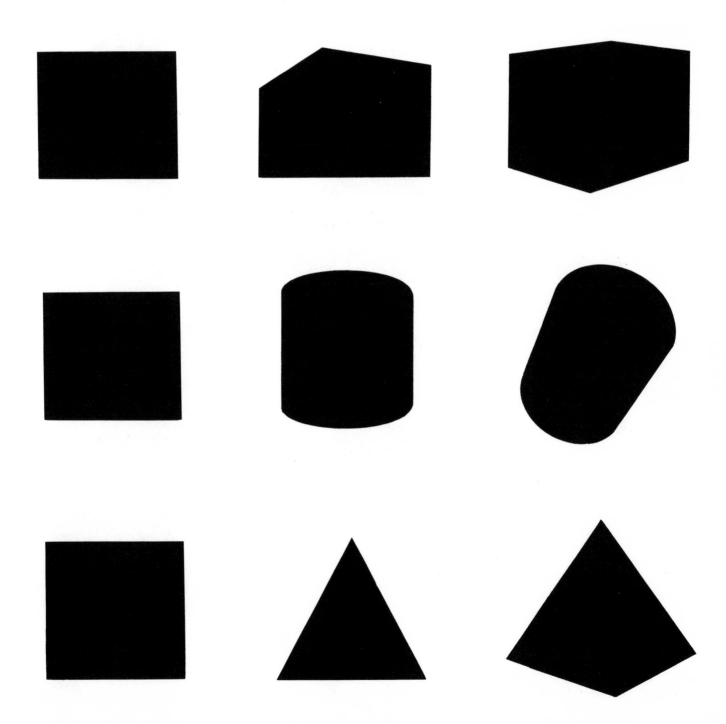

11

The Silhouette and the Third Dimension

If we are to understand the silhouette as a real presence in the world, we must see some suggestion of the third dimension, as seen in the foregoing examples. A clear, unambiguous silhouette depends on finding the right viewpoint—a view of the object that gives a sense of perspective, a grasp of the whole form. To achieve this sense of perspective, the drawing must communicate the presence of a ground plane on which the form rests.

Balancing Figures

This action silhouette is believable because the feet of the lower figure seem to rest on a base line. The athlete's legs communicate a firm sense of the ground. Throughout the two figures, there is also a clear sense of the vertical line of gravity.

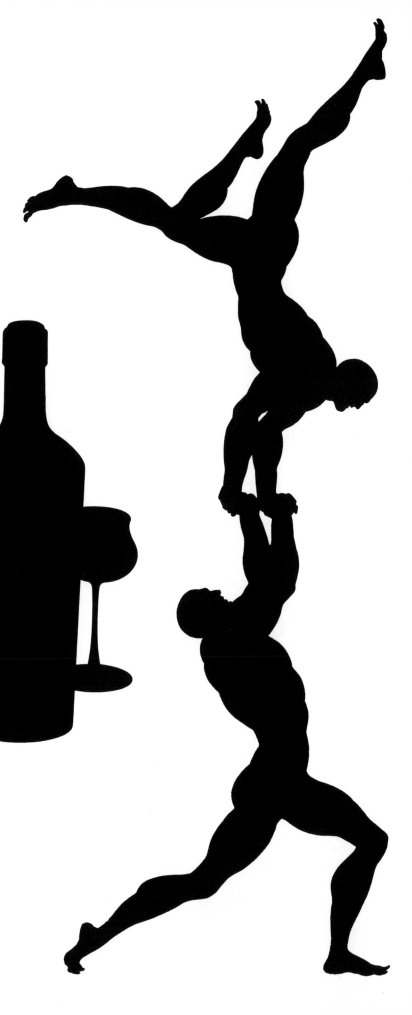

Objects on a Table

The silhouettes of the bottle, wine glasses, cork, and box all imply the presence of a table top. The objects not only seem to exist in a field of light and space, but also communicate a definite front-to-back relationship. At the right, the overlap of the wine glass and bottle signals the fact that the glass stands behind the bottle. As for the cylindrical cork that lies on its side, the right side seems nearer to you than the left side. All this happens because the silhouettes imply perspective and the presence of a ground plane—the table top.

House

Seen in perspective from above, this silhouette shows us a large house with wings attached to the main structure. Look at the topmost line of the roof: does the rooftop recede from left to right or from right to left? Looking at the total silhouette and studying the visual logic of all the other structures, you know that the form of the roof recedes from left to right. The back of the house is at your right.

Objects on a Drawing Board

The pen, brush, ink and paint bottles, eyeglasses, eraser, leads, and coffee cup are not parallel to one another but are all at odd angles. Yet they seem "right" because each silhouette makes us feel, without question, the presence of the firm, flat surface of the drawing table on which the objects rest. For each object, the best viewpoint—the best angle—has been chosen to suggest that the white paper is not just a field of light, but a dimensional space. Note the left lens of the eyeglasses. The magnification of the temple piece *through* the lens and the patch of light *on* the lens are powerful visual signals that convey the illusion of the third dimension.

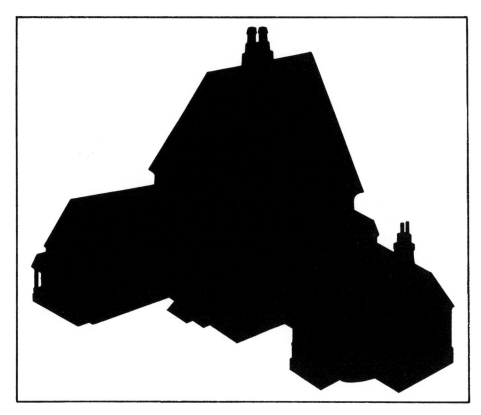

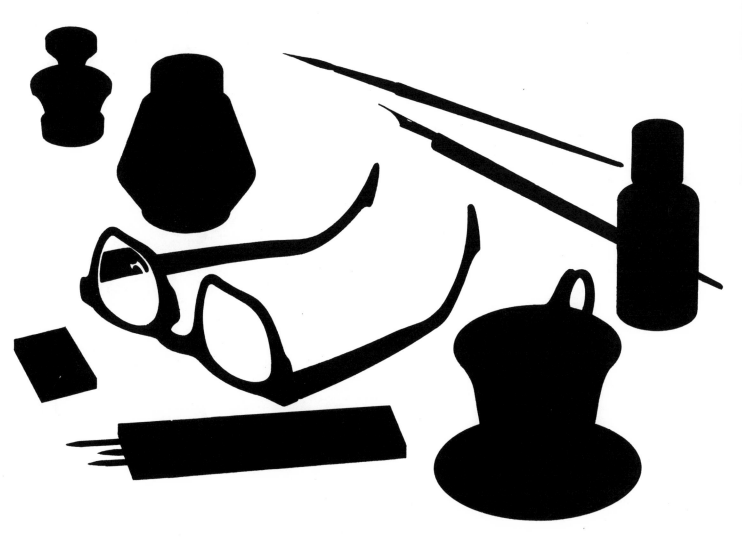

Silhouette Figures in Space

The silhouette of the human figure presents problems because we do not have precise geometric forms to work with, as we do in the preceding example. And there are still more problems when we deal with the soft, plastic form of the human body in groups. The figure requires new perceptions.

Fight Scene

Here is a scene with many figures in various stages of action. Study the actions and the shapes carefully, and do not be put off by the multiple arms and legs, which are meant to show *action sequences* in some figures. Start with the tense, angular, straight-legged figure who moves diagonally upward from the lower right, holding and heaving a figure at the upper left. From here, the design moves downward, counterclockwise, to the left. As you look at each figure, try to imagine front views, back views, twists in the torsos, right and left legs. As your eye moves, you will perceive space and depth. The horizontal figure in the lower right—a back view, is it not?—establishes the much-needed ground plane or base line.

More Figures in Action
There is an important difference between this group of fighting figures and the group in the preceding illustration. In this rotating design, the central figure and one or two others move *toward* us and *away* from us. If you study the silhouettes of the arms and legs, and especially the fingers and toes, you will become acutely aware of how the details of the silhouettes convey depth. Contrary to what you may think, the silhouette does not necessarily lie profiled on the flat paper like a skinned animal rug on a floor, but has rich possibilities for conveying three-dimensional space.

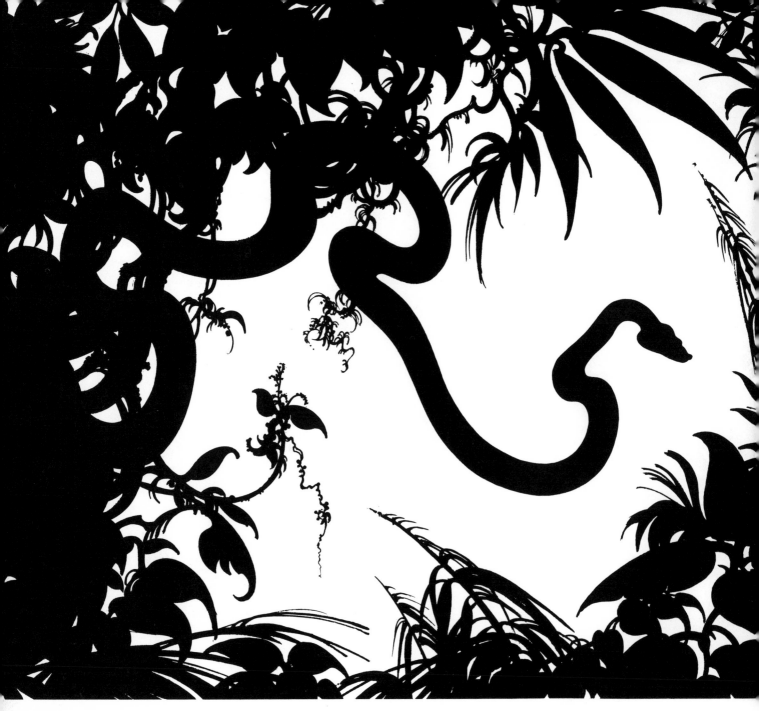

Silhouettes Can Convey Degrees of Light
Although we have only the white paper to communicate the brightness of the light, the silhouette can actually suggest differences in the amount or degree of light—greater or lesser *intensity* of light.

Jungle Scene
As a large tree boa emerges from a jungle setting, the network of leaves, vines, fronds, and tropical verdure along the edges seems *darker* than in the central, open area. The central space appears bright, indeed; else, why would the serpent appear so sharp and clear in contrast with the murky, indistinct shapes of the surrounding jungle? Let your eye move back and forth from the center to the edges to confirm this impression. Along the edges, the dense concentration of dark silhouettes somehow makes black ink look blacker! Spatial question: Look around the boundary and ask yourself whether the boa is moving *away* from you into the picture or outward *toward* you.

Leopard

In contrast to the foregoing illustration, this view of a leopard in a tree is generally dark throughout. Most elements of the picture are in the foreground, but there is still a sense of depth and spatial definition. See how the tail of the animal curls, and observe the overlapping leaves at the top as well as the curling tree trunk and branches.

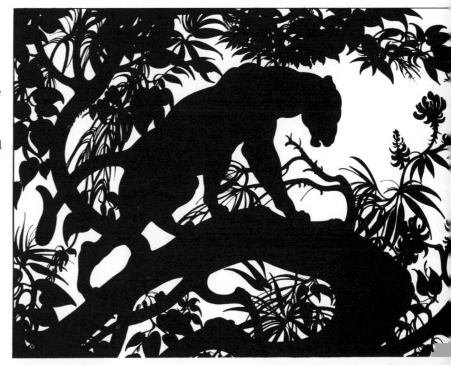

Jungle Man

A dark foreground is implied in this image of a figure in a tree, accompanied by monkeys and surrounded by dense tropical growth. The silhouette of the figure communicates a foreshortened top view. To analyze the action of the body, look at such details as the twist of the torso, the forward thrust of the left arm, the hair of the eyelash, and the upraised little toe of the left foot. Do you feel that the pattern of light and dark in the drawing begins to suggest *color*—cool tonalities of green, blue, and purple, with a sunny contrast of yellows and greens where the lion travels across the open ground beneath?

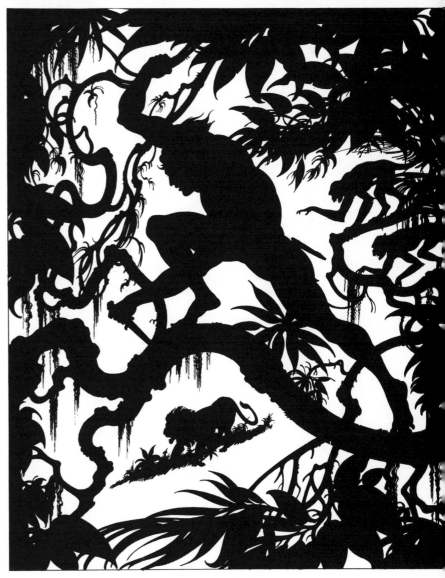

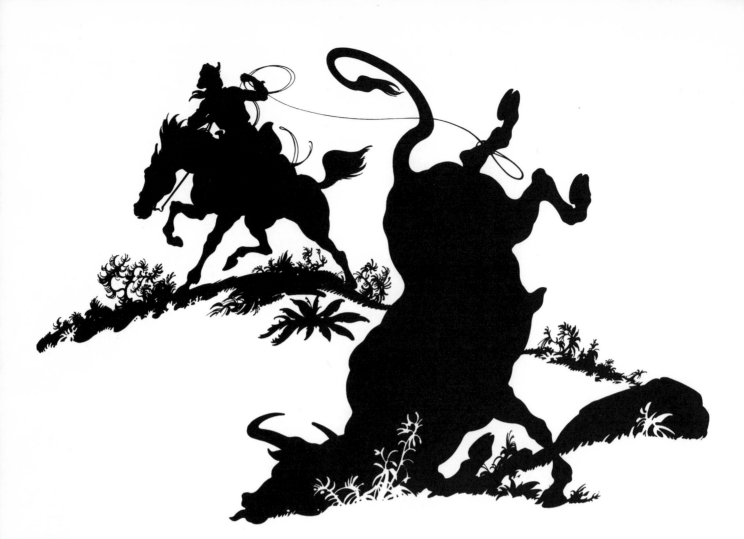

Different Silhouette Sizes
Create Perspective

A change of size in known elements—that is, in objects whose size we already know from experience—will communicate a sense of deep space. The bigger shape looks closer, while the smaller one looks farther away.

Cowboy in Action

As the cowboy ropes the steer and drops him to the ground, we have a clear sense of the foreground plane where the animal falls and the background plane where the cowboy rides his horse. Several changes in scale are at work here: the difference in the sizes of the animals, near and far; the diminishing sizes of the plants in the foreground and distance; and the rise and fall of the shapes of the ground. And notice how the lariat grows thicker as it moves from the cowboy's hand to the rear leg of the steer.

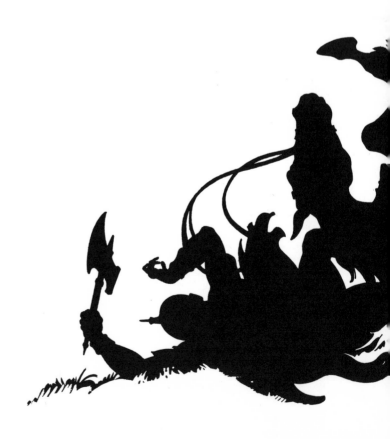

Reverse Silhouettes

Silhouettes can become even more complex to create a particularly complicated sense of three-dimensional space. One possibility is a *dual system* of what might be called "reverse silhouettes," black-on-white *and* white-on-black. The combination can be so subtle that we hardly notice.

Warriors on Horseback

The silhouettes tell us that the *nearer* horseman is at the right, while the fallen horseman at the left is slightly *farther* away. The rumps of the horses are the key: we feel that we see them from behind, and this seems consistent with the three-quarter back view of the horseman raising his ax. The confirmation, subtle as it is, appears in the black-and-white silhouettes of the grass. The upright rear leg of the striding horse is in *front* of the grass, while the body of the fallen horse is *behind* the grass, which we see in white silhouette against the dark body. Note the silhouette of the head of the fallen horse; we seem to see the head from under the jaw. The message: Never lose an opportunity to relate facts in a silhouette.

19

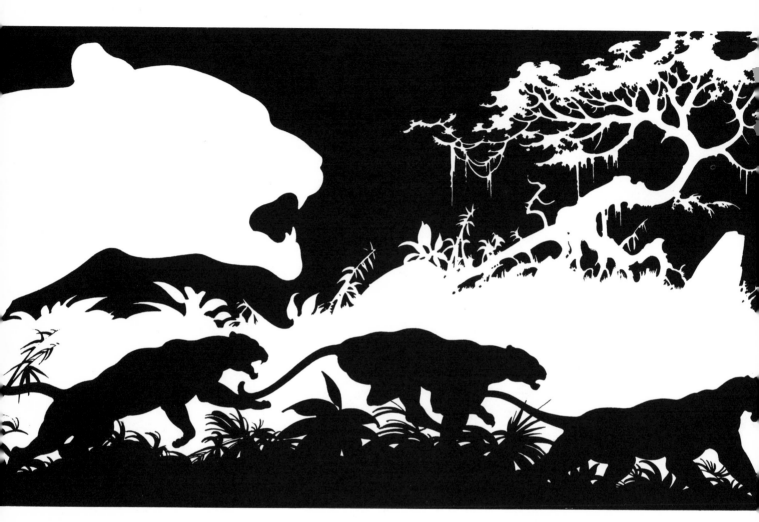

A Frieze of Leopards

A three-stage design of black-on-white and white-on-black produces an interesting spatial effect. In the upper left, the white shape of the leopard's head appears to be in the immediate foreground. Then the black shapes of the running cats—against the white background—become the middleground. Finally, the white-on-black panorama of trees, grasses, and verdure—behind the black cats—functions as the background, against which we can see the foreground and middleground without confusion. The design is both decorative and functional.

Swamp

In another three-stage silhouette design, the planes are not separated, as in the previous illustration, but overlapped and interconnected. The immediate foreground is represented by the black silhouette of the swampy growth at the bottom of the picture. The black shape quickly overlaps the white silhouette just behind, representing lush, swampy growth, a leaping hare on the land, and a jumping frog on the water. This white silhouette, in turn, overlaps the black silhouette of the rocks, turtle, sapling, more elaborate tropical growth, and the startled heron about to take flight. Such a drawing demands careful planning and painstaking execution. There are virtually no shortcuts. But the reward is an effective and "colorful" work in black-and-white that has all the earmarks of a satisfying rendering in full color.

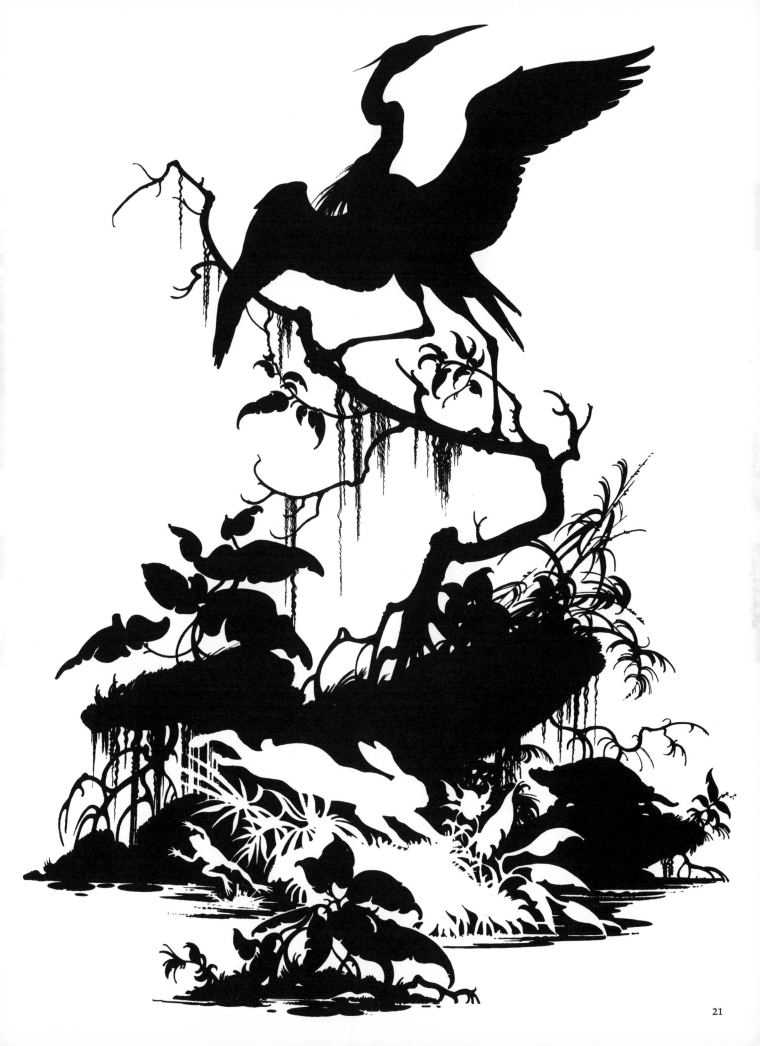

MINIMAL LIGHT

The Primary Definition of Form
I shall never forget painting a studio still life in my student days. I was struggling to get some *form* into my painting of a big, green bottle. But the paint lay on the surface like dead matter. The instructor walked by, squinted at my painting, and said: "There are two things you do with form. First, you push the object *into* the surface—you send it back in depth. Then you get it *off* the surface, free it, force it out!" So saying, he picked up a brushload of white, made a curving slash on my green bottle, and the form swelled, leaping from the canvas with the most beautiful highlight I have ever seen.

You have seen that the *silhouette* is the first and simplest impression of the total contour of a form in space. The simplest essence of a form in *three dimensions* is in the *highlight*. Although the highlight is the most minimal light possible, that highlight signifies the outward thrust of the form as it advances from the picture plane toward the viewer. Attached to the silhouette, which defines the contour of the form most clearly, the highlight adds the third dimension and communicates the object's outward movement into space.

Varying the Direction of the Light
Do not be troubled by the recurrent use of a single-light direction—from the upper right—in these drawings or in your own. Sometimes the continued use of a simple, logical solution reinforces your performance. But if you need a new light source, just hold these drawings up to a mirror and you will see how the light works when it comes from the opposite direction. Or rotate the drawings as you please—even turning them upside down—to discover new light directions.

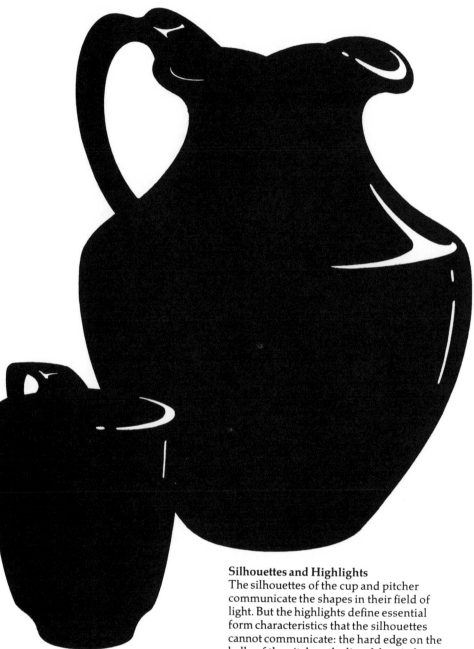

Silhouettes and Highlights
The silhouettes of the cup and pitcher communicate the shapes in their field of light. But the highlights define essential form characteristics that the silhouettes cannot communicate: the hard edge on the belly of the pitcher; the lip of the pitcher; the forms of the cup and pitcher handles; and the overlapping curve of the cup in front of the pitcher. The lesson: Try not to neglect any salient piece of information about a form, but see if you can communicate its existence with a highlight.

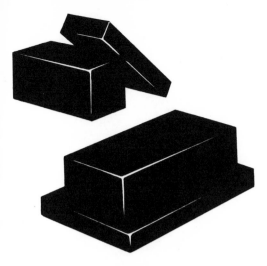

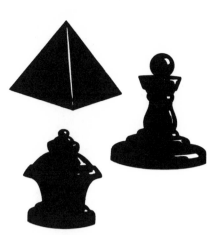

Highlights on Edges

These hard-edged, rectangular forms are explained by highlights that follow the vertical and horizontal edges of the planes. The highlights all start from the projecting corners. Note the direction of the light, which moves into the corner of each box form and then tapers away along the receding edges of the planes. The choice of the light direction is entirely arbitrary—selected to show the form most clearly. If your choice of light *reads well*, let no one tell you that it is wrong!

Matching the Highlight to the Form

For each form, the highlights are chosen to explain the shape most clearly. On the pyramid, all that is needed is a linear highlight on the forward triangular corner. For the chess pieces, a light source has been placed slightly above and to one side, and the highlights tend to repeat the external contours. In each case, the form is explicit and discernible.

Variations within the Highlight

Note that the highlight thickens at certain points. This accent or stress within the highlight clearly denotes the point of the form that is closest to the light source. Where the highlight tapers and gradually disappears on a curved or receding surface, the narrowing highlight suggests places where the highlight becomes diminished or vague. The needle and thread obviously need no additional light to explain the form; they exist very clearly as simple, pristine silhouettes.

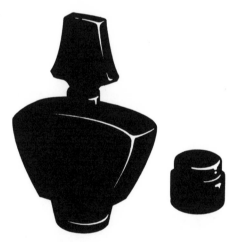

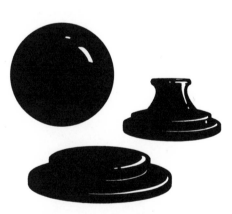

Inward and Outward Curves

The two cosmetic bottles, one large and one small, show convex and concave curves, both in their silhouettes and in the highlights that follow these silhouettes. Once the silhouette is explained by the simplest means—by the simplest and most explicit minimal light—there is nothing more to be done.

Making Forms Recognizable

Just as it is essential to choose the silhouette that shows the object in its most recognizable, unambiguous contour, you must choose the highlights that reveal the form most clearly. In this drawing of spherical and disk-shaped objects, the problem is to show the essential changes in the forms as revealed by the highlights. Although they are *not* drawn from actual models, these silhouettes and highlights communicate effectively for two reasons. First, all the lights come from one direction—from the upper right, at an angle of roughly forty-five degrees. Second, the minimal lights (highlights) within the silhouettes tend to repeat the nearest external contours.

Inventing Light Sources

In this drawing of disparate objects on a drawing board, the minimal lights (highlights) do not reflect a single, consistent light source. The direction of the light varies and the highlights have been invented to express the salient forms with maximum clarity. Where the brush hairs emanate from the metal holder of the disk eraser, for example, the highlight is designed to reveal the series of tiny indentures that clamp the hairs. This invented highlight is simple and convincing. Never overlook a necessary form; a lazy statement is worse than none.

**Edge Light—Another Use
of Minimal Light**
Simple, minimal light—the highlight—is
the most economical means of revealing
three-dimensional form within a sil-
houette. Edge light is another, secondary
use of minimal light that may be com-
bined with the highlight to enhance three-
dimensional form. This combination is es-
pecially effective in drawings or paintings
of the figure.

Combining Highlights and Edge Lights
These two figures, shown largely in sil-
houette, show minimal highlights within
the forms. On the right figure, there are *is-
lands* of minimal light on the features of
the head, on the neck and chest, and on the
hand that holds the staff. The left figure
shows similar droplets of light on the but-
tock, fists, left shoulder, neck, and other
areas. These highlights are used selec-
tively to clarify or express certain forms or
actions that are essential to the drawing.
For the same purpose, edge lights have
been introduced (largely on the tops and
right sides of the forms) to show muscle
stress on the shoulders; tensions within
the tendons of arms, hands, and feet on
the ground plane; pulls within the chest
and legs; and the overlap of the crossed
staves.

24

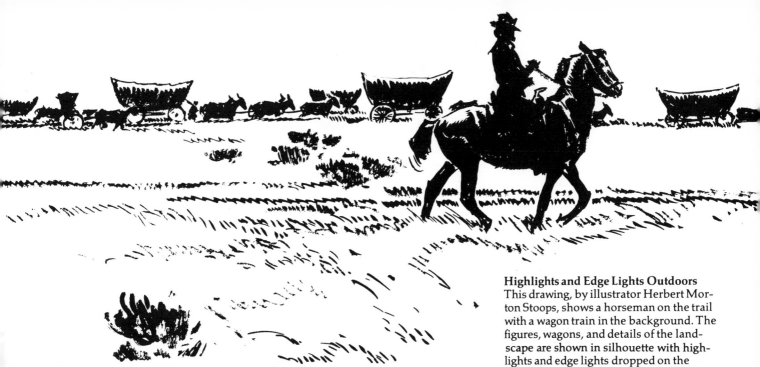

Highlights and Edge Lights Outdoors
This drawing, by illustrator Herbert Morton Stoops, shows a horseman on the trail with a wagon train in the background. The figures, wagons, and details of the landscape are shown in silhouette with highlights and edge lights dropped on the forms by the sun overhead. The ground is spare and open, with a very economical use of texture in the shrubs and grass.

Edge Light Alone
Here, minimal edge light is used without the intervention of any highlights within the silhouette. What we have, in effect, is another kind of highlight formulation. The figure appears in a dark field. Notice how dramatic and compelling such light can be. This is the mode of light that we may define as the historical mode called "Baroque chiaroscuro."

Versatility of Minimal Light
The net effect of all these examples is to show the versatility and power of minimal light when added to the silhouette, and to open the way to new properties of light and shade. We will begin to define a number of these properties in the next chapter.

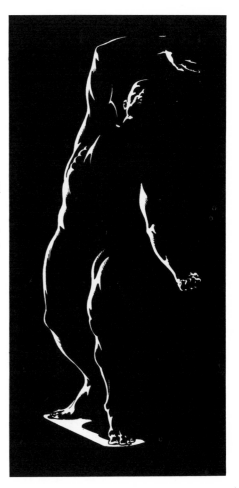

FIVE CATEGORIES OF LIGHT AND SHADE

Five Kinds of Light

For the purposes of the artist, I believe that there are five kinds of light—and their corresponding kinds of shade—that tend to fit almost all the light conditions that we are likely to draw or paint: single-source light; double-source light; flat, diffused light; moonlight; and sculptural light. I will introduce them briefly in this chapter. Then, in the following chapters, I will explain and illustrate each type of light and shade in greater detail.

Single-Source Light

The simplest kind of light comes from a single source, such as the bright light of the sun on a warm summer's day, in the late morning, at midday, or in early afternoon. This single-source light—or *direct* light—may also occur in an interior setting, where there is a bright, artificial light coming from a fairly high, overhead source. Whatever the season or time of day, and whatever the setting, indoors or outdoors, the net effect is a bright light with a correspondingly deep, sharp-edged shadow. Thus, *direct, single-source light* can also mean bright light illumination by photo flash, fluorescent tube, flame, arc, fireworks, dynamite, lightning, and so forth.

Single-Source Light from the Upper Left

In this two-figure group, the direct, single-source light comes from the upper left—almost overhead. Compare the soft-edged *flesh shadows* on the volumes of the bodies with the hard-edged *cast shadows*. The falling light has thrown cast shadows on the neck, chest, and legs of the upright figure, which has, in turn, thrown a strip of shadow on the prone figure. The cast shadow on the ground combines the shapes of the two figures in simplified form. There is a critical difference between the two kinds of shadows. *Flesh* or *body shadow* is integral to the figure and expresses the particular qualities of the form. *Cast shadow*, on the other hand, does not belong to the figure, but is *imposed* on the form.

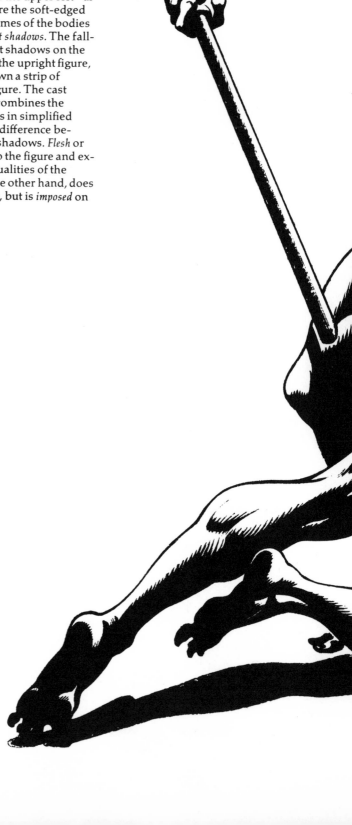

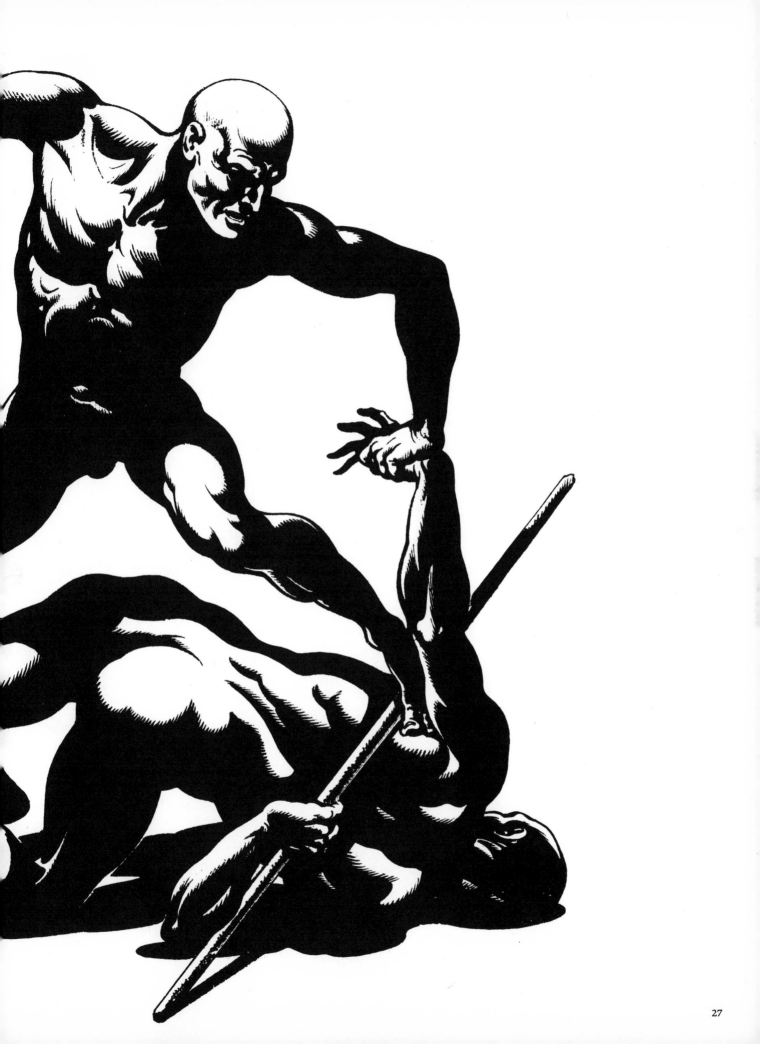

**Single-Source Light
from the Upper Right**
This sketch of a part of Rodin's *John the Baptist Preaching* shows the effect of a high light source in the upper right, somewhat in front of the figure. Even in such a spontaneous sketch—with the tones quickly applied in the shaded areas—the shadows clearly follow the linear edges of the planes.

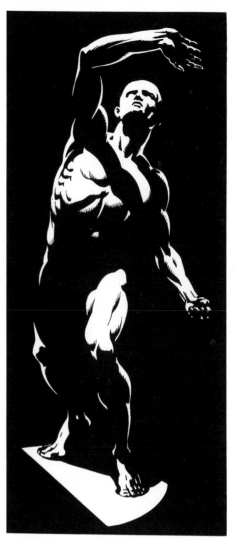

Artificial Light Indoors
This figure is brightly illuminated by an artificial light source, such as a spotlight, within the interior space of a room. The light source is virtually overhead, and the background recedes immediately into darkness. Note the hard-edged cast shadow of the arm falling across the chest. The thigh emerges from a hard-edged dark into the "hot" light. But see how some of the fleshy forms emerge from the darkness more slowly and subtly; study the feathered edges of the tones.

Double-Source Light

The second category of light and shade is a combination of two light sources: strong, direct light from one source; and a secondary, lesser light from some opposite source, away from the strong, primary light source. Thus, we now have major and minor light, or direct and indirect light. And this kind of light and shade can occur either outdoors or indoors, whether the light source is natural or artificial.

Double-Source Light Outdoors

The young woman's head, drawn outdoors, shows the *primary* natural light coming from the upper right. This light direction is confirmed by the direction of the cast shadows under the nose and lower lip, and on the neck below the chin. The light is not harsh, but muted and atmospheric, suggesting an outdoor setting among a grove of trees or some wooded area that will reflect and diffuse the light. Thus, the *secondary* or minor light hovers softly on the left side of the face. The dark area within the center of the head falls between the *major* light on the right and the *minor* light on the left.

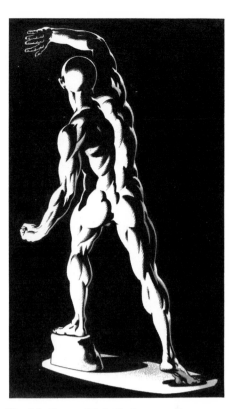

Double-Source Light Indoors

Now we see this dual light system on a figure indoors. On the left side of the form is the major, direct light. On the right side of the form is the minor, indirect light, thrown on the figure from some distant part of the room. The cast shadows under the left arm and on the upraised right arm—created by the obstructing head—tell us that the primary, or direct light source is at the lower left. Observe how the secondary, indirect light at the right tends to repeat the outer contour of the figure—and remember the discussion of this phenomenon in the preceding chapter on minimal light.

29

Flat, Diffused Light

Flat, diffused light occurs on overcast days, beneath cloudy skies, and tends to be cool, cheerless, and dreary, rather than bright, warm, and sunny. Indoors, such light has a screened, low intensity, averted character. There is a tendency toward overall shadow in this low key, moody light, projecting solemnity and melancholy.

Flat, Diffused Light Outdoors

This kind of light tends to reduce forms to simple planes, flat and semiabstract shapes that deny the third dimension. The murky light seems timeless: the time could be early morning without sun, late afternoon, twilight, a rainy day in early spring, or a damp day in late fall. The mood is oppressive and downcast.

Flat, Diffused Light Indoors

Caught in half light from the right, possibly a reflected light or a light from a remote window, the vague darks keep the figure from emerging clearly. The general tendency of flat, diffused indoor light is to reduce the form to a shadowy presence. Merging into darkness, the forms and contours lose their clarity, except for the faint accents of light on the skull and the right shoulder. Bear in mind that these are not the only possibilities of flat, diffused light. Others will be discussed subsequently.

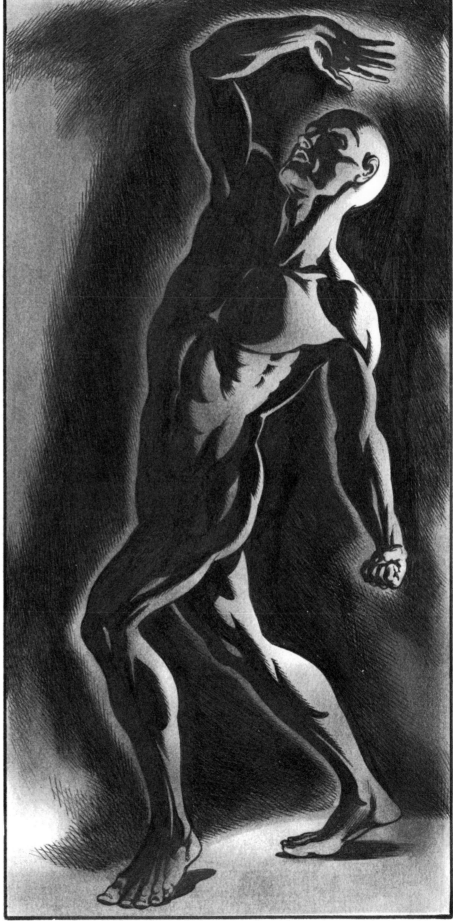

Moonlight—Single and Double Source

Moonlight is essentially single-source light—for example, a clear sky with a bright moon illuminating a wide, unobstructed space. But moonlight in a closed or restricted space—a lane surrounded by trees, a city street, or an outdoor passageway—may be reflected or bounced from various surfaces. Thus, we may have the *direct*, primary light of the moon and the *indirect*, secondary, reflected light. In moonlight, the environment is generally dark; shadows and silhouettes preponderate. It is also important to remember that moonlight is, in itself, reflected light—light received from the sun and then reflected off the surface of the moon. Thus, moonlight cannot be as bright as anything that gives off light from its own internal combustion, such as a torch, or even a match. The light of the moon is cool and silvery.

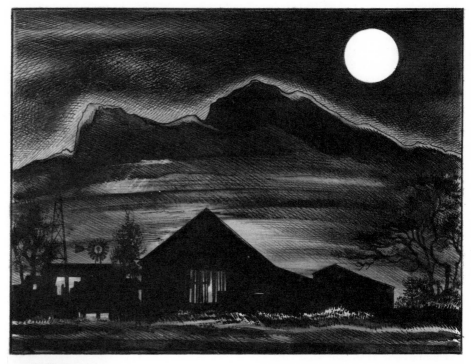

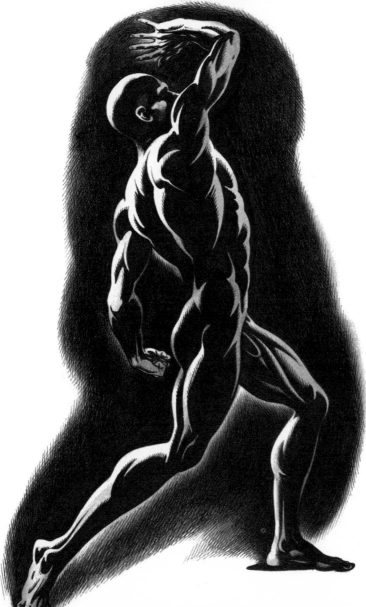

Moonlight Outdoors

Generalized darkness prevails in this moonlit landscape. The foreground trees, buildings, shrubs, and grass are seen mostly in silhouette. Against a darkened background, the trees are unclear, and the whole foreground tends to be vague, except for the detail defined by the lights within the building. The deep tone of the sky recedes behind the silver disk of the moon, while a halo of light rises behind the hills, suggesting a cool night mist. The drifting mist in the valley—in the middleground—also catches something of the moonlight.

Moonlight Indoors

Here we have a figure in an interior space that catches the direct light of the moon from one direction, and also produces a secondary, reflected light from another direction. The direct, major light comes from the moon in the upper left, casting the brightest light on forms that tend to be perpendicular to the direction of the light—such as the top of the skull, the shoulders, and the calves. The indirect, minor light comes from the right. The background is dark, of course, but has an airy feeling.

Sculptural Light

This light system is one of the most interesting and compelling ways to define form. I use the word *system* because this is not a light that you actually see, but an arbitrary light that you *invent* to explore every aspect of the form, explaining everything, leaving out nothing. It is tempting to call this *tactile light* because you run the light over every turn and detail of the form. And like a fingertip, the light feels and records every detail of its volume. The light starts at the front of every form, then grows fainter as the form turns away from the light and recedes into darkness. Thus, the centers of the forms are brightly lit, while the edges turn away into shadow. The system assumes a middling-bright, daytime light source. And the lights and shadows are invented quite arbitrarily for maximum comprehension.

Sculptural Light on a Figure

This downward view of a female figure may look as if it is lighted from above, but it is not. In reality, each form receives the maximum light at the high point of the bulge; then the receding forms bend away into darkness at the edges. Within each form, the gradation from light to dark corresponds to the turning of the shape from high to low. Thus, the head is light at the top, dropping off to darkness at the back and sides of the skull. Following a similar strategy, light and dark contrasts are used to signify the fact that one form is higher or lower than another. Thus, the dark bulge of the head rises above the lighted chest. In the same way, the lighted thigh rises above the shadowy belly, which turns downward into darkness. This is not a logical kind of light that you can see in nature. It is an arbitrary, invented light—a sculptural light that is based on your sense of touch, your tactile awareness of the form as it moves toward you and away from you.

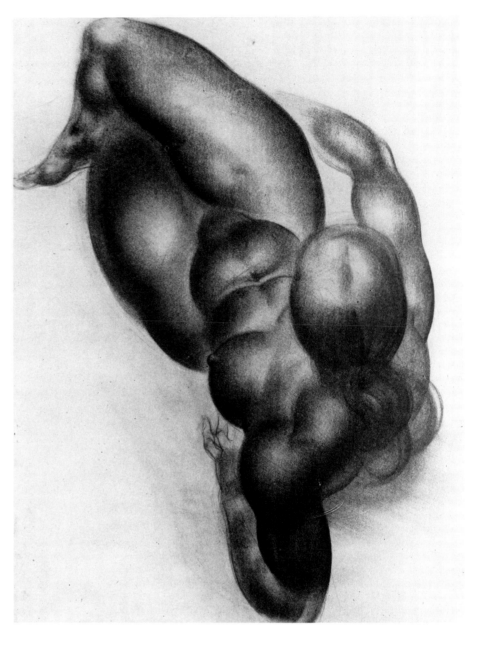

Sculptural Light on a Head

At first, the light seems to come from above the head, and this seems to be confirmed by the cast shadows under the nose, cigar, lower lip, and neck. But the dark areas on the hair disavow top light. And the features seem to receive their light from directly in front. For each form, a light has been invented to reveal that form with the greatest clarity, generally beginning with bright light at the center of the form and then working around to shadow at the margins. This *could* mean chaos, but the drawing is held together by the precise drawing of the contours and the tones that follow these contours on all sides. Thus, *each form* is visualized as a sculptural entity, and so this collection of particular forms becomes a unified, coherent whole.

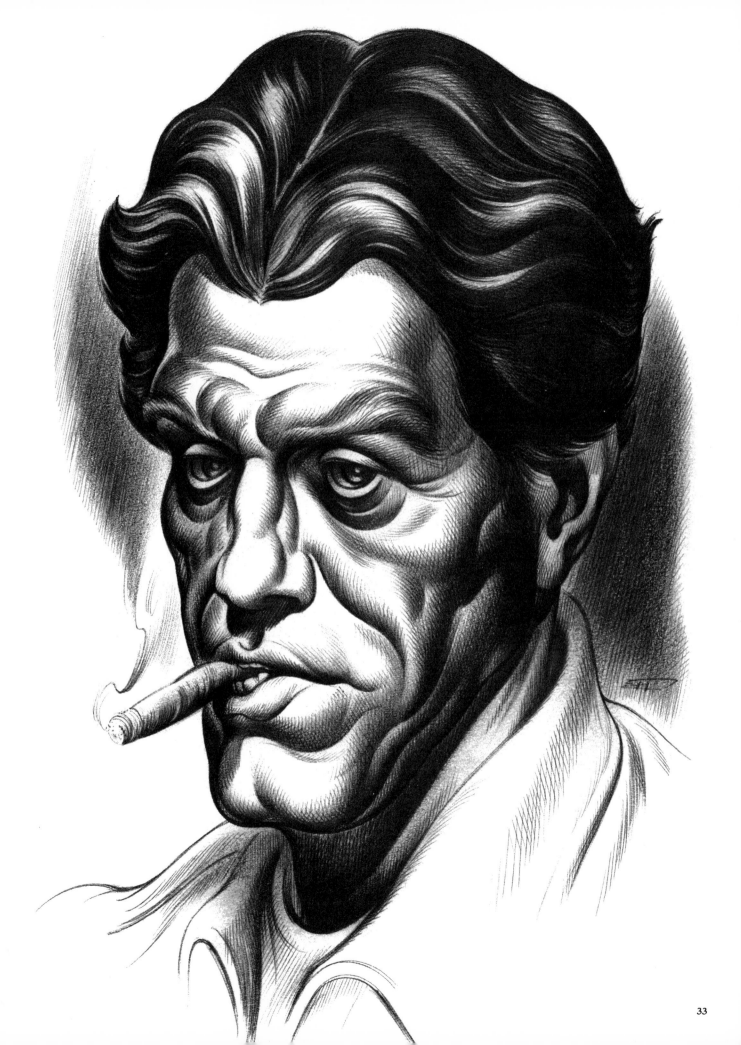

33

SINGLE-SOURCE LIGHT

Equivalent Light and Shadow
In the previous chapter, you have seen that direct, single-source light can be warm, bright sunlight or strong artificial light, such as a floodlight or a photoflash might produce. Such illumination normally implies the presence of strong shadows as well. In fact, we may say that lights and shadows are *mutual*; that is, a shadow must correspond to the light in degree of brightness or intensity. Simply stated, strong light means strong shadow, and weak light means weak shadow.

Chiaroscuro
In the history of art, direct, single-source light with its strong, concomitant shadow has come to be known as *chiaroscuro*. It is familiar in the work of such masters as Caravaggio, Rembrandt, La Tour, and other painters of dramatic lighting effects. Such light is also used in theater and film, where intense, focused light enhances powerful emotions, passionate moods, and tragic plots.

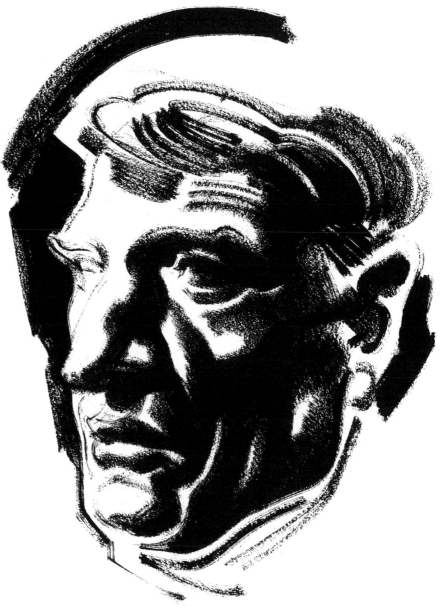

Single-Source Light on Head
In this straightforward brush drawing of a head, the contrast is evident between the bright light and the corresponding dark shadow. The firm, dark edges of the features contrast powerfully with the white paper to elicit the effect of strong light. On the left side of the face, the black background intensifies the lighted contour. This illuminated area, in turn, matches the dark value of the facial mass at the right.

Head in Outdoor Light
Unlike the spotlight of the previous illustration, this head is illuminated by warm sunlight, with some other reflecting surfaces nearby. The soft-edged, airy shadows, the play of secondary reflected lights at the left, and the lesser values of the ear, jaw, and the back of the head, all suggest atmospheric outdoor light. The barely noticeable outline at the right completes the impression of the warm light of a summer day.

Head in Reduced Light
When direct light is reduced, whether indoors or outdoors, there is less intensity and less contrast, as you see in this example. Here, as the light loses its brightness, the shadows become paler, and the entire effect of the drawing is distinctly paler. If the reduction of the light continued, the next stage would be flat, diffused light. Flat light will be discussed in a later chapter.

**Figure in Direct
Side Light**
This athlete, plunging toward
the water, is illuminated by an
overhead light source that
strikes the figure from the
right. The light produces a con-
sistent bright edge on the right-
hand contours of the forms,
leaving most of the figure in
deep shadow. The strength and
brilliance of the light is verified
by the cast shadows: the
shadow of one foot on the
other; the shadow of the shoul-
der on the back of the head;
and the darkness of the lower
arm, which is in the shadow
cast by the head and chest.

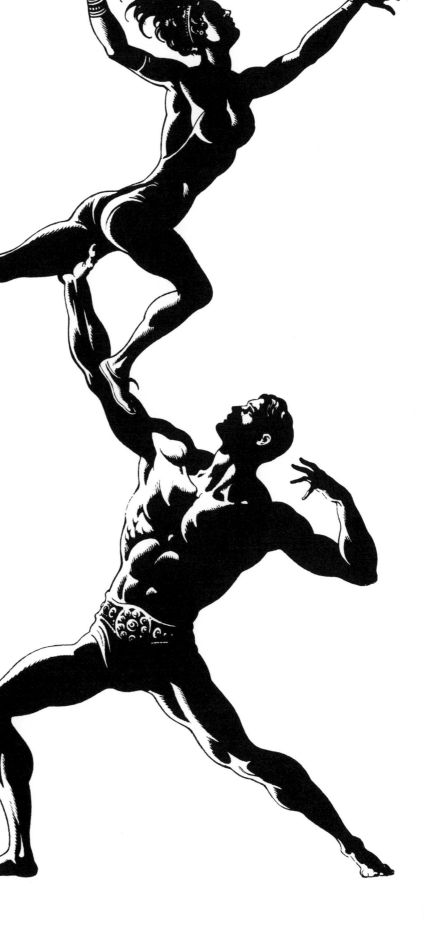

Figures in Edge and Front Light

The acrobats are illuminated by a light source that is high and to the left. On the back of the woman aloft, we see edge light, but we see more light on the front of the male figure. The strength of the light is evident in the cast shadows on the woman's right shoulder and arm, and on the man's shoulder and face. Because this is an indoor theatrical event, with performers in costume, we perceive the light source to be bright artificial light. Conversely, because the subject of the diving athlete in the previous drawing is obviously an outdoor subject, we infer that the light source is sunlight. Our *experience* tells us what kind of light we are seeing.

**Figures in High,
Direct Light**
The edges of these two figures
are illuminated by a high light
source at the right. Depending
upon the movements of the
forms and their relationship to
the light, some forms are in
deep shadow (such as the tor-
sos), while other forms (such as
the arms) show an intricate
play of light. Cast shadows are
eliminated to let the positions
of the feet create a convincing
sense of the ground plane.

Indoors or Outdoors?
The dark background and the minimal
rim light at the back of each head suggest a
closed interior space. Surely, we know
that the minimal rim light comes from
some nearby reflecting background sur-
face. But the strong light that comes from
the upper left, producing cast shadows
and soft-edged darks on the forms, sug-
gests sunlight—as if the figures are emerg-
ing from some closed space into bright
sunlight outside. What do *you* think?

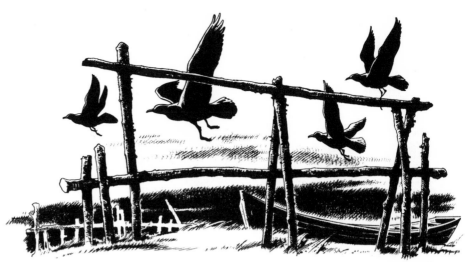

Seaside in Direct, Single-Source Light
It is daytime at the shore, but cool and chilly, with a feeling of the dreary end of summer. The high, single-source light produces edge lights on the birds as they fly into the wind, projecting darkly against the sky. The fence in the foreground, **edge-lit like the birds,** is silhouetted against a field of light that is obviously not warm, not bright. The oncoming dark to the rear, close to the ground, suggests overcast weather, a drop in temperature, perhaps rain. The distant fence is a white silhouette that emerges from the wind-driven grass like the pale bones of some creature, bleaching in the salt air.

**Single-Source Light
with Dark Background**
Direct, single-source light from the right illumines a racing yacht, scudding home against a brisk, darkening sky. Edge lights appear on the sails, lit by the low sun that glows on the curves of the billowing canvas. Light also breaks atop the wave patterns that sweep swiftly by. The sky above the water is still brightened by the fading sun; but higher up, the oncoming clouds tell us that the light will soon be overtaken by a stormy night and booming seas.

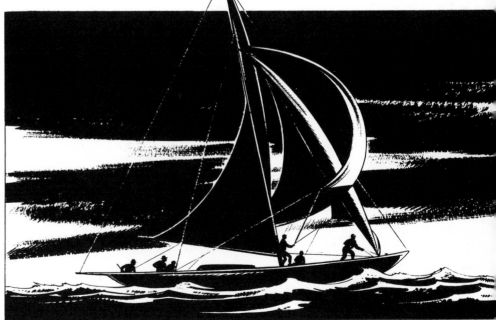

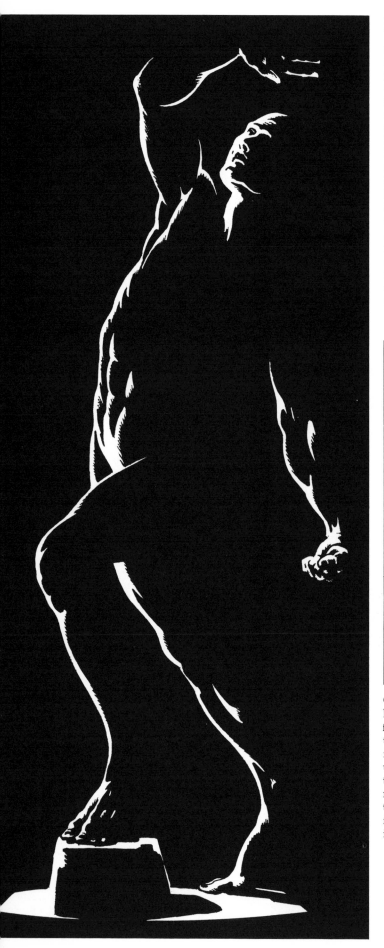

Chiaroscuro—Upper Left

This drawing and the next four are examples of high-contrast edge light, the dramatic and powerful effect known as *chiaroscuro*. Translated literally from the Italian, the word means "light-dark," and describes the characteristic lighting of much late Renaissance, Mannerist, and Baroque painting. The interior light on this figure comes from the upper left side. The vivid illumination produces extreme contrast. Because there is no secondary light source to create reflected light on the dark side of the figure, the contours on the right side have slipped away, undefined in the Stygian darkness.

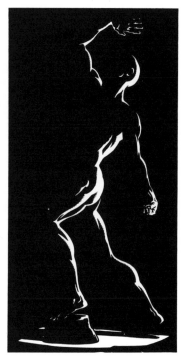

Chiaroscuro—Right

Like the previous drawing, the figure is strongly edge-lit, but the light comes from the right—from a midpoint about halfway up the form. The other side of the figure is in absolute darkness once again. It is instructive to see how such a complete form can be developed in minimal light.

Chiaroscuro—Lower Right

Now the edge light comes from the lower right-hand side. Note the wider expanse of the light on the under forms of the figure: the calf muscles, thighs and buttocks, chest, and back of the skull. Also study the clenched hand in the lower right, the higher extended arm, and the open fingers of the raised hand in this low side light.

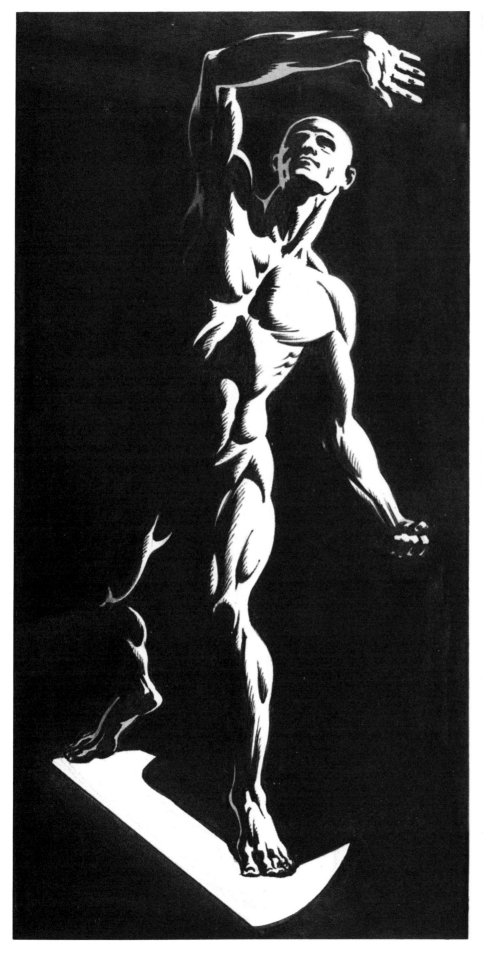

Chiaroscuro—One-Third Front
The light shifts to expose one third of the front of the figure. The light source is high. You can verify this by examining how the right side of the head, the right chest area, and the right thigh are illuminated. Other forms are partially lit on the right, except for the open palm, which is fully lit above the head. The left contours remain in darkness, since the room interior is dark and there are no reflecting surfaces to bounce light into the shadows. But there are some minor *underlights* beneath the high arm and on the left of the face; these are reflected lights that bounce off nearby parts of the figure itself. Thus, the left side of the head catches reflected light from the biceps nearby, but throws its own cast shadow on the shoulder.

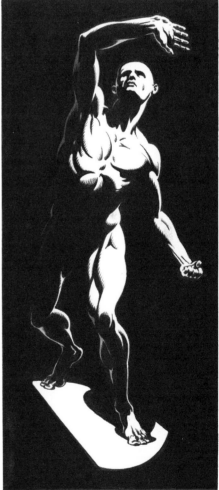

Chiaroscuro—Two-Thirds Front
Still another light shift illuminates two thirds of the front of the figure. Again, the light source is high. As you did when you looked at the previous illustration, study the lighting on the face, chest, and upper leg at the right, and identify the bounced underlights.

Overhead Light

Strong light from directly overhead creates deep pools of shadow in the major underplanes of the head. A network of deep shadows spreads over the head, connecting the shadows with one another and with the background. The dark eye sockets slip into the cheekbone depressions, which interlock with the darks of the jaw, neck, ear, hair, and background beyond. When strong, hot light produces correspondingly deep shadows, the lighter tones tend to be overridden and may seem to disappear altogether—as they often do in the paintings of Caravaggio and Ribera.

Less Intense Light

Less intense light, suggesting more air and atmosphere, projects a gentler, less dramatic mood. The light source is high and strikes the front of the head, as we can verify by finding the cast shadows under the nose and lips, and on the neck beneath the jaw. The soft, transparent, atmospheric light lets us see *into* the forms that are overlaid with transparent shadow, so that the surface forms of the skin are soft and palpable.

Muted Light
This head is suffused with a muted, low-key light that comes from above the middle of the face. The main light centers on the nose. From here, a system of *graduated lights* recedes in all directions—upward, sideward, downward—becoming less intense, and supported by corresponding darks. See how the sharpest contrasts are at the center of the head, where the most vivid light prevails. Then see how the light and shade grow softer and fuzzier as they move away from the center, becoming somewhat lost and vague in the region of the base of the chin and the rear of the head.

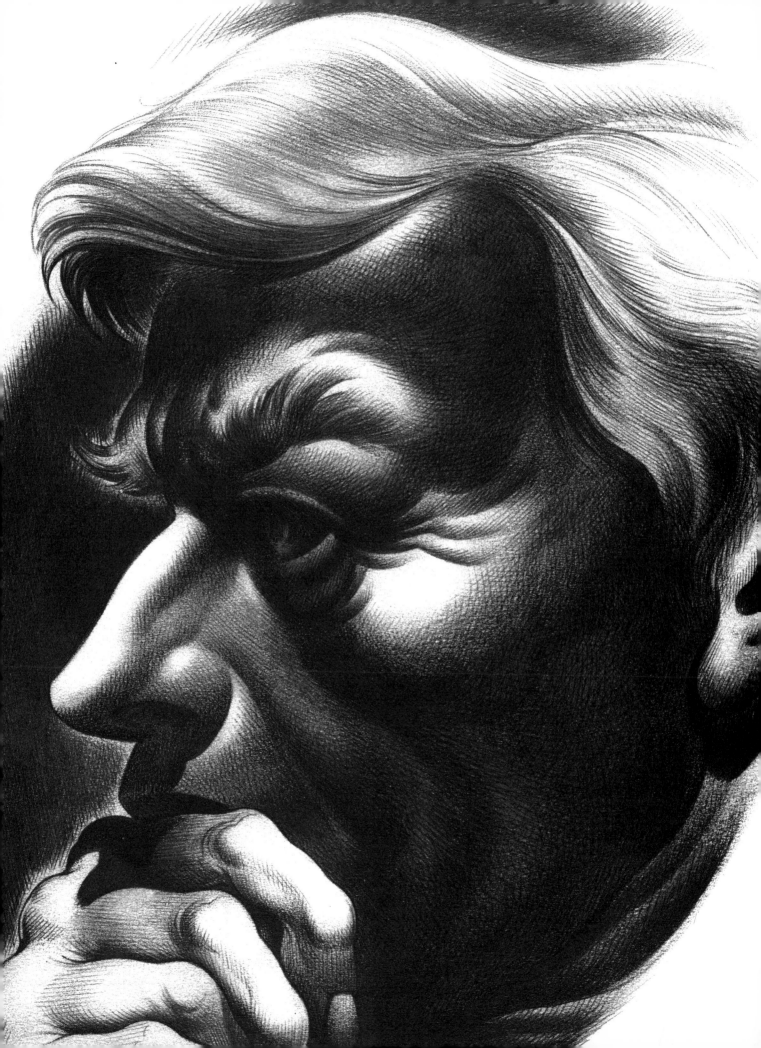

Bright, Restricted Light
This profile head, illuminated from a high source, displays the effect of bright light that is restricted in its coverage of the form. The narrow light falls on just a few areas, but produces deep shadows on virtually all the oblique and vertical planes of the head. Note how a shadow drops straight down from the nose to the lip and forefinger. Take time to observe an interesting detail: the lower edge of the eye is partially illuminated by a minor light, possibly bouncing off some lower form, such as the nose or a finger.

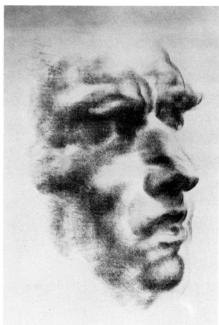

Atmospheric Light △
When the light is not vivid, strong, or bright, it takes on an aerial or atmospheric quality. Linear elements disappear. Firm, hard-edged forms give way to pliable, fluent, or vaporous forms. In this partial head, there is hardly a line. The tones are airy, powdery, like gases of varying densities.

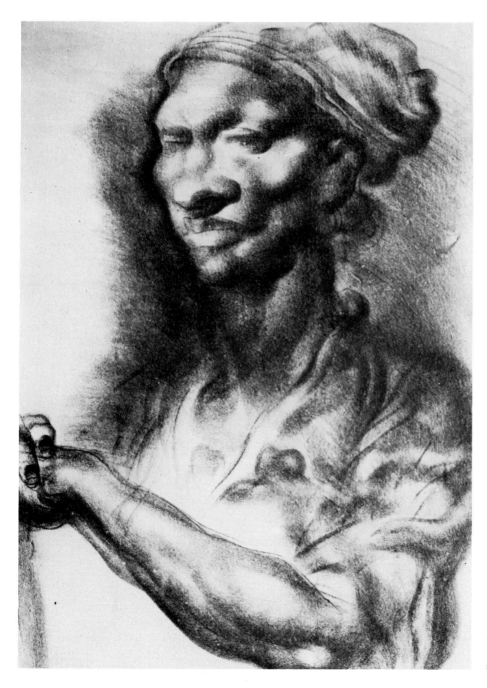

Atmospheric Light—Another Example
Like the preceding head, this figure tends to exist in a misty environment. The semi-transparent light seems to filter through a haze—with occasional accents here and there on the forms. Contours and details are minimized in this dusty, atmospheric light. Forms appear and disappear in a "lost-and-found" fashion. Some forms seem quite close to one another, while others seem distant. The nose is clearly up front, while the neck, shoulders, and hair seem far away.

Low Light Source

Direct light from a low source usually implies firelight in a darkened environment, whether indoors or outdoors. Such light suggests romance or melodrama—and this kind of light is obviously impossible during the day. This figure is lit from the lower left by a strong, artificial source like a photoflood. The light emanates outside the lower left leg, creating shadows that run up the length of the body. Certain obstructions produce cast shadows on the right thigh, chest, neck, and head. Against the unyielding darkness, see how warm and bright this light can be.

Low Light Disrupts Form

The low light source is near the lower face. Illuminating just a few low-lying planes, the hot, hard light sets up a field of darkness that disrupts the forms of the head. With two thirds of the head in darkness, the encroaching background tends to merge with the forms to suppress information about the contours. Note the islands of light within the dark areas. This is hardly enough information to elicit meaningful forms. But your drawing will be convincing if you plan the structure carefully and if your lighting is logically related to the planes.

Firelight

The warm glow of firelight in cold weather, outdoors, creates a soft, airy illumination from below. The air is not coldly clear, so we see some crystalline diffusion of the light, with soft-edged forms emerging from the surrounding darkness. The forms are rendered with oblique strokes that follow the light upward from the lower right toward the upper left.

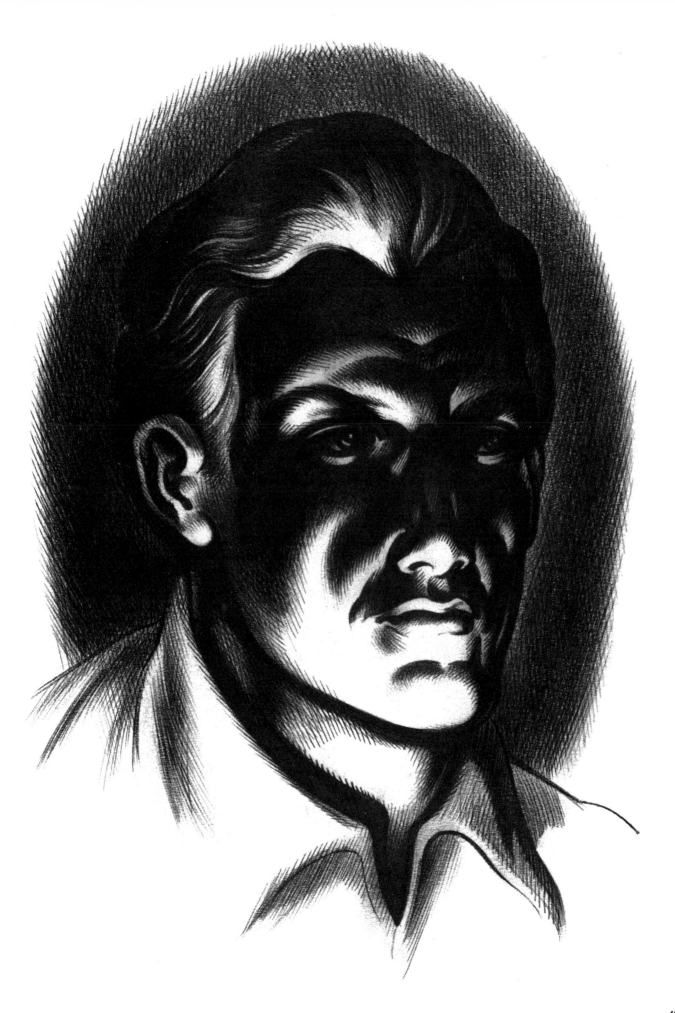

CHAPTER 5
DOUBLE-SOURCE LIGHT

Major and Minor Light
As you have already seen in Chapter 3, double-source light is produced by a major source and a minor source. The major or *direct* source is almost always hot and luminous, such as sunlight, electric light, or firelight. The minor or *indirect* source is normally thrown from a reflecting surface that is opposite the major or direct source. The indirect or minor light is usually less intense than the major light—unless we get a *mirror reflection* of the major source.

Outdoors and Indoors
Double-source light occurs in both exterior and interior environments, particularly in closed spaces where there are many possible reflecting surfaces. In a natural, outdoor setting, we see these paired lights in groves, arbors, lanes in woods, ravines, caves, hollows, ledges, and similar formations. Indoors, double-source light is common in room interiors, corridors, and especially in studios where artificial lighting—such as floodlights and spotlights—may be combined with reflectors to manipulate direct and indirect light.

Intensity
In contrast with the warmth and brilliance of the major light source, light that projects from a reflecting surface tends to be cool and reduced in its intensity. However, it is important to observe that the major light, despite its greater intensity, may not necessarily illuminate a larger area than the minor, reflected light. Indeed, the minor light may sometimes cover a greater area.

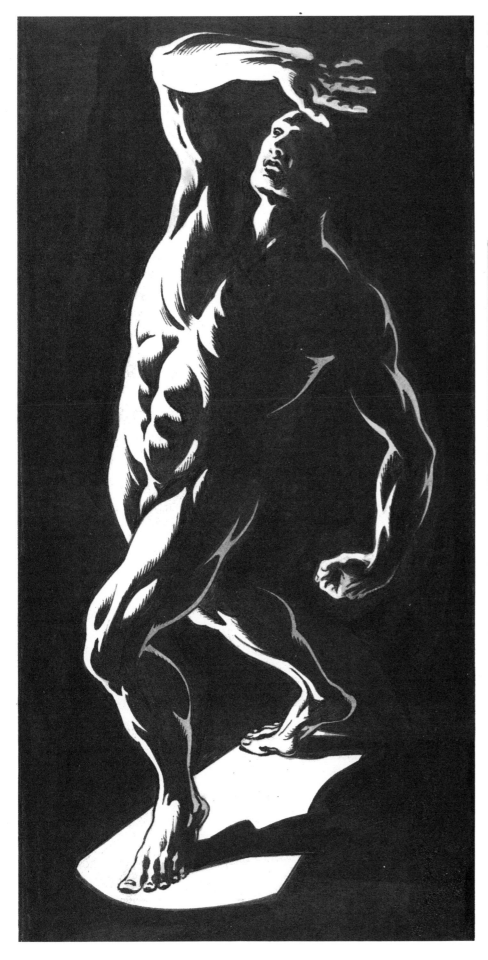

Front and Back
On this figure in a closed interior space, the major light source illuminates the side of the body and much of the front. The minor, reflected light comes from the right rear—with the minimal light following the edge of the form and repeating the contours of the body.

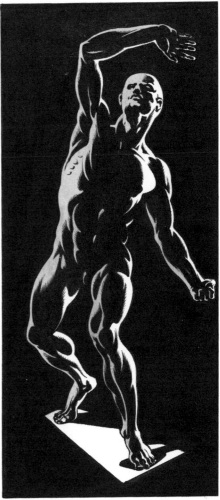

Right and Left
When the figure is turned almost fully to the front, we see an interesting play of contours. The major light comes from the right, revealing a smaller area than the previous drawing, while the minor light comes from the left and covers more of the body. It is particularly easy to comprehend the forms in this light. For example, see how clearly the light explains the complicated hookup of the shoulders to the chest and thorax. If you want to learn the subtle network of the figure and its forms, use double-source light to reveal the richness of the interior contours.

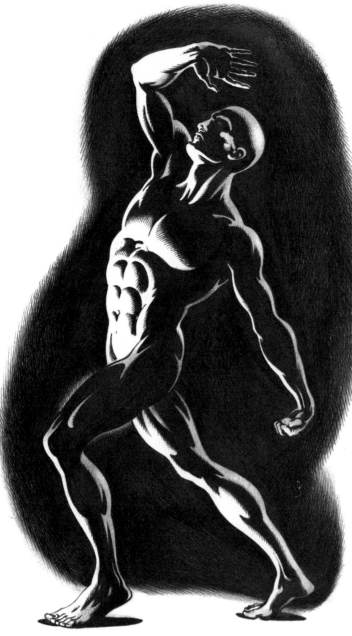

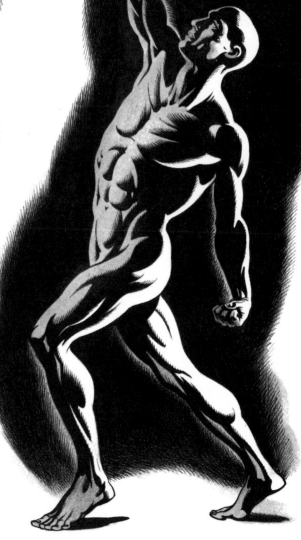

Low Major Light Source
Like firelight or footlights, the light source comes from below and in front of the body, striking the legs, belly, chest, neck, jaw, and raised forearm. By contrast, the cool, reflected light on the opposite side of the form tends to retreat into the dark background, serving to reinforce the brilliance of the primary light source.

High Major Light Source
When the primary light source shifts to a high rear location, we see a sequence of active forms on the right. On the opposite side, a cool, subdued, indirect light reveals the front of the figure. Although we see more of the figure's left side in this minor light, the luminous major light source is still dominant. Compare these last two illustrations. See how much hotter the light looks in the previous drawing, and how much cooler it looks in this one.

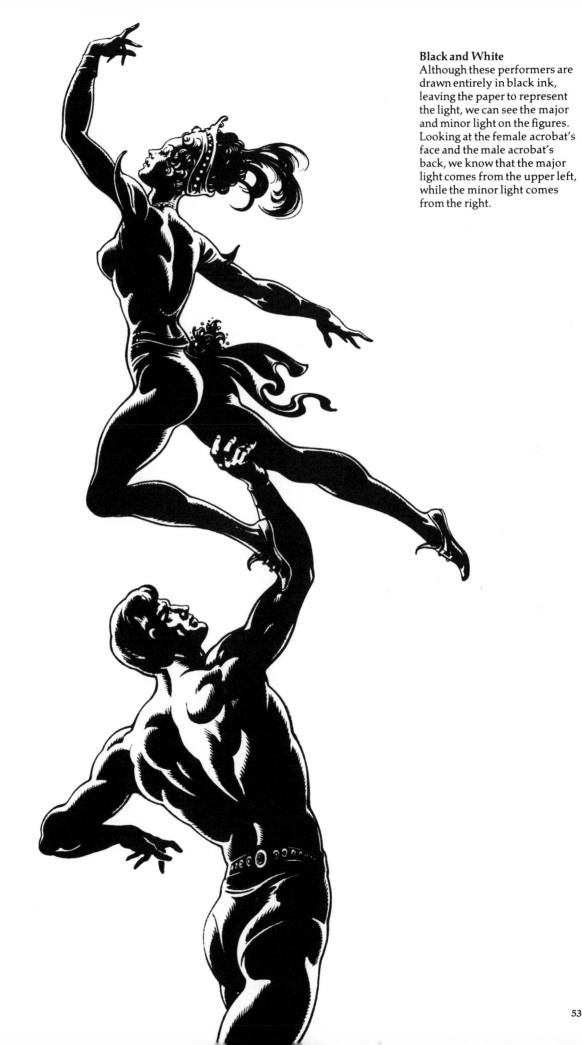

Black and White
Although these performers are drawn entirely in black ink, leaving the paper to represent the light, we can see the major and minor light on the figures. Looking at the female acrobat's face and the male acrobat's back, we know that the major light comes from the upper left, while the minor light comes from the right.

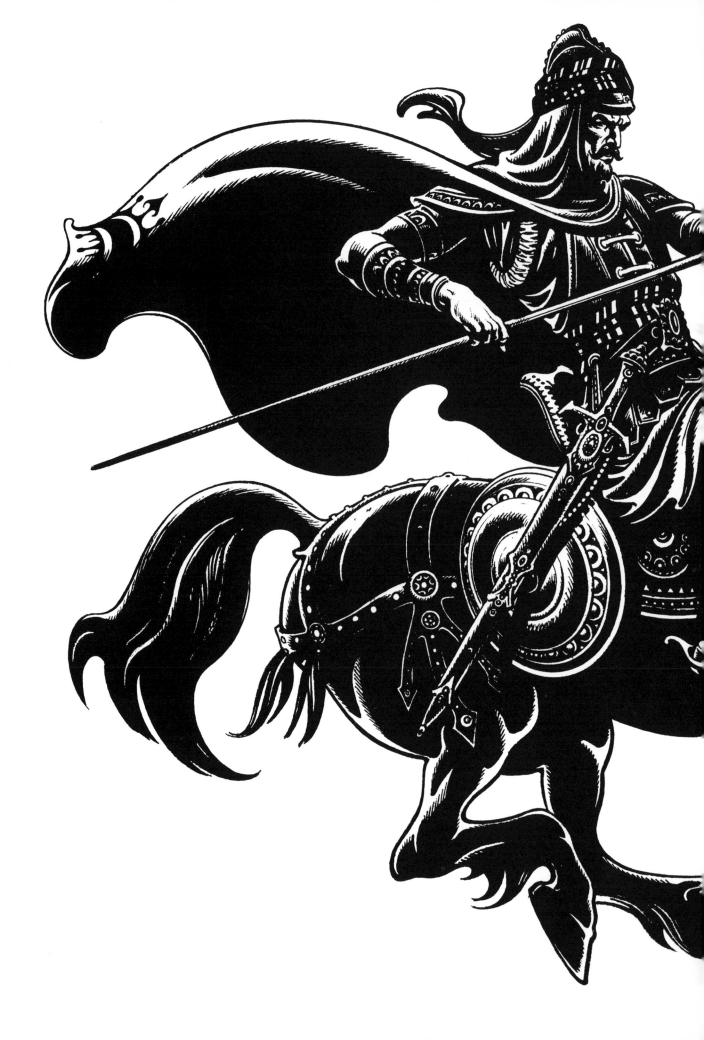

Another Black and White
Without the subtle grays that define the lights in earlier drawings, this ink drawing affirms that the major light source is at the right. This is evident in the face, hands, and knee of the rider, and in the head and forelegs of the horse. The direction of the horse and rider reinforce this conclusion about the direction of the light.

Shadow in Double-Source Light

When you draw a shadow in double-source light, remember that the darkest edge of a form is next to the brightest light on that form. Study the shadow on the side of the nose. The tone is darkest where it meets the light plane on the front of the nose *and* where it meets the lighted cheek. Between these two darks, the shadow on the side of the nose grows pale, as if it contains a minor reflected light. Observe a similar effect on the shadow side of the face, where the dark edges of the brow and cheek meet the lighted frontal planes of the forehead and face.

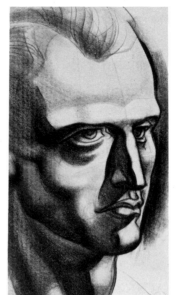

Another Example of Shadow

In this study of a head, the brightest light comes from the right to meet the stressed dark edges of the shadows on the side of the nose, brow, cheek, jaw, chin, and neck. Once again, note the lesser values within the shadows, suggesting secondary, reflected lights. Without the accented forward edges of the shadows, the head would lose much of its strong feeling of three-dimensional form.

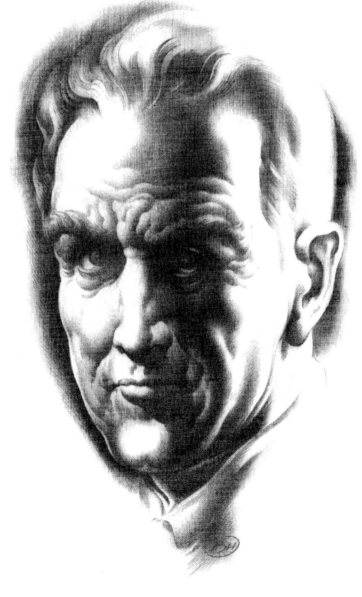

Dominant Reflected Light

Indirect light can be remarkably versatile. Here, the minor light comes from the left and dominates the head, while the supposedly major light actually plays a lesser role. It is in the soft, indirect light that we see the animated eye, the detail of the cheek and corner of the mouth, and the wrinkles of the brow. The major light from the right tends to conceal detail by its very brightness, and also plunges the adjacent area of the face into profound darkness, leaving this side of the head almost neutral of expression. Again, note that the darkest shadows are on the right, next to the areas of brightest light.

Forms in Reflected Light

The major light at the right exposes only about one third of the entire head mass. Most of the forms are in the reflected light at the left. Yet the upturned head receives the full brilliance of the light on the features, while the underplanes, interesting as they may be, are played down by the preponderant shadow. Observe the shadow that has been placed arbitrarily on the ear to prevent the bright form from becoming distracting.

Unpredictable Light

There are times when the behavior of the major and minor light may not be predictable. This person is in an outdoor setting where the varied reflecting surfaces tend to create a dappled, spotty effect, like the light under a tree. The major light, from high on the right, is hot and bright; the eye squints and the mouth is compressed. The secondary light is the uncertain one, dappled, capricious, and hard to define. The dark edges of the shadows are sometimes lost, sometimes found. Intermittent pulses of bright light appear without apparent cause among the wrinkles and furrows in the shadow areas of the forehead, brow, eyes, and mouth. To draw such a head, you must develop a thorough knowledge of facial forms, and you must be able to draw what you *see*, abandoning many of your normal assumptions about light and shade.

Equal Intensity

In this front view of a male head, the light is of equal intensity on both sides of the form. There is no major or minor light, as we have come to define them. Although the forms on both sides of the head are illuminated by two light sources of equal strength, it is important to observe that the lighted areas are *not* identical—because no head is truly symmetrical.

Profile in Equal Light

Here is another example of a head in which the two light sources are equally strong. On the front and back of the head, the lights are of similar intensity, but the viewer unconditionally decides that the profile is of *major* interest and the rear of the head is a *minor* consideration. Because the profile demands examination, while the back of the head elicits only casual interest, we might *still* say that the major light falls on the front of the face after all.

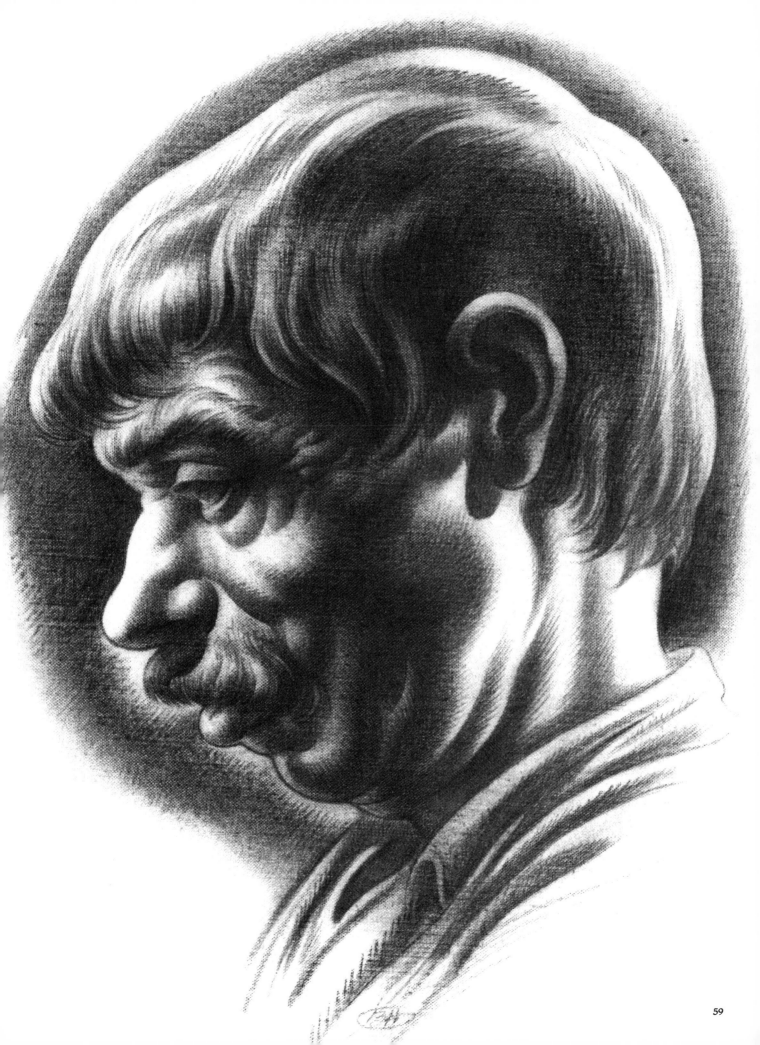

Soft Light, Soft Shadow

The major light at the right is comfortably bright, but not brilliant. Thus, the corresponding shadows in the balance of the head are soft-edged and airy. The accented dark edge of the shadow is next to the brightest light on the right side. The minor light at the rear sets off the shape of the hair and admits some light to define the ornament above the ear. Study the background tone, front and back. See how the tones become darker or brighter to contrast with the contours of the head, which are also sometimes darker and sometimes brighter. The pencil strokes are angled to follow the direction of the light from the upper right to the lower left.

Incidental Light

This elderly black man has a lustrous skin surface, like burnished copper, that creates a complex light effect. The major light is at the upper left, above the ovoid crown of the skull, which glows with a high luster. As the light descends, it glows on similar forms, like the tip of the nose, the wing of the nostril, and the lower lip. On the right side of the head, observe the pale reflected lights that also fluctuate on the contours. Throughout the head, reflected light seems to gleam as it is caught in crevices and projections, producing what might be called *incidental light*—light independent of the major and minor light sources.

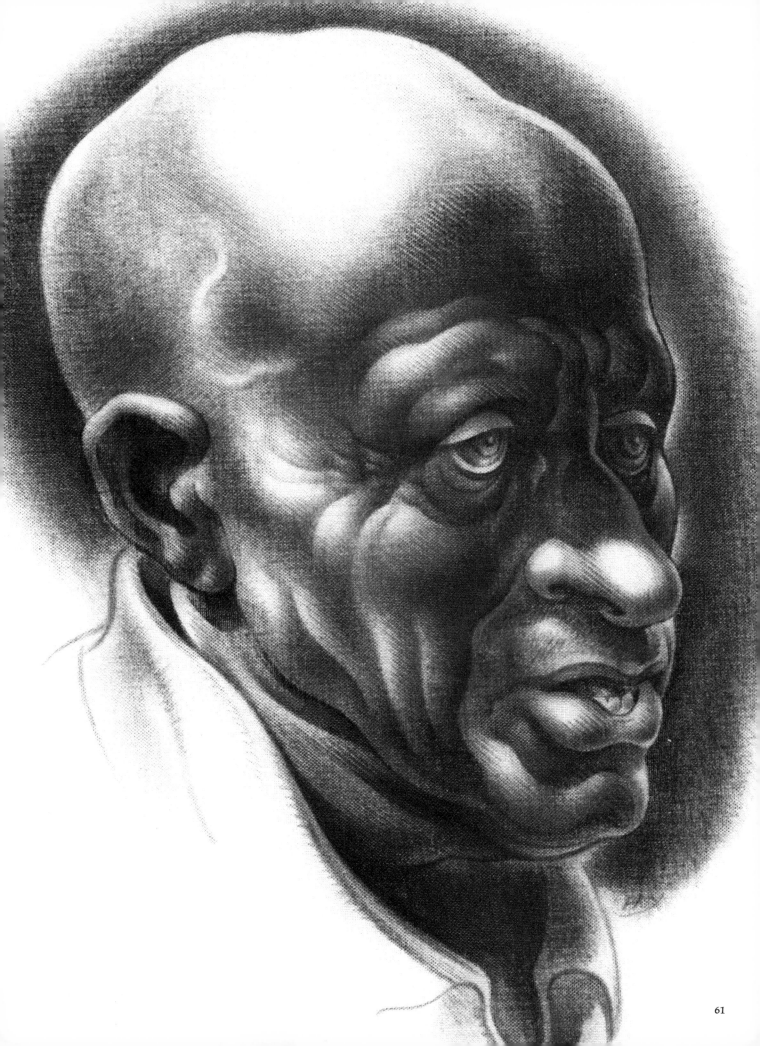

61

Wrinkled Skin

Wrinkles and furrows in aging skin create another complexity when you draw a head in double-source light. This older woman displays a network of wrinkles, flickering across her face. What is the best way to draw this head? In this drawing, the solution is twofold. On the right side, the shadow is condensed and solidified to minimize detail. On the left, the shadow remains open and transparent, revealing the details of the skin. Thus, complexity is balanced by simplicity. There is just enough detail to convey the character of the sitter's skin, but not enough detail to overwhelm the viewer and shatter the image.

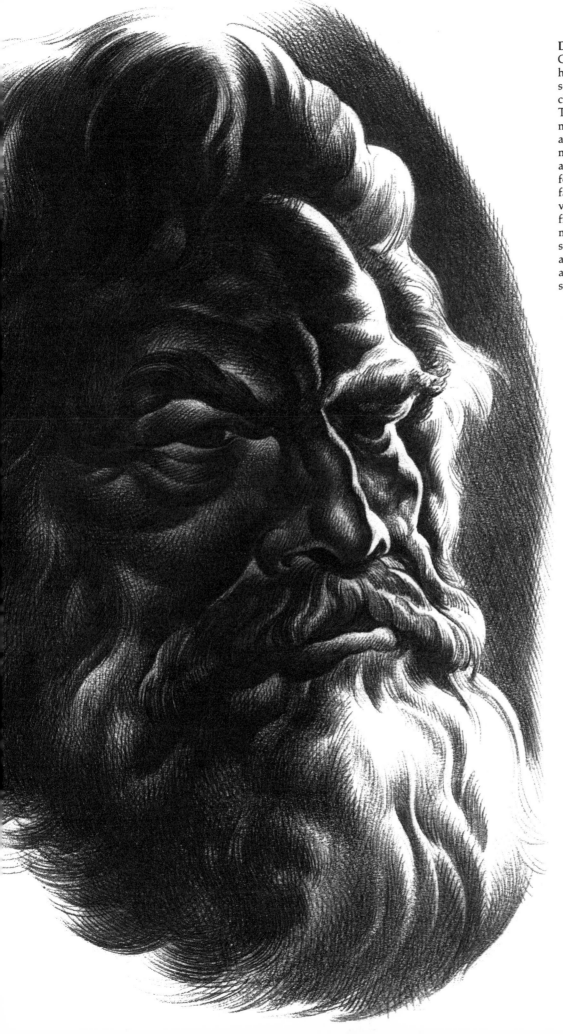

Dark Against Light
Covering seven-eighths of the head, the shadow is condensed, solidified, and simplified to include the hair, face, and beard. The details within this shadow mass are defined by minimal amounts of reflected light. The mass of darkness is balanced against the active, exciting forms of the lighted side of the face, which are revealed by a very limited amount of light from the major source. Learn to make creative use of double-source light, balancing bright and dim, large and small, active and passive areas of light and shadow.

CHAPTER 6
FLAT, DIFFUSED LIGHT

Diffused Light Is Flat
A cloudy or overcast sky normally produces diffused light. It is also created by haze, mist, fog, smoke, dust, and incipient rain or snow. These conditions produce flat light because they reduce the contrast between light and shadow—shadows become pale, vague, and ill-defined. They even put the direction of the light source in question. Thus diffused light tends to flatten forms, often producing patterned shapes and silhouettes that become gray and ghostly in rain, snow, and dense fog. Diffused, flat light is cool, not warm or sunny, and is an excellent device for producing a mood of solemnity, melancholy, or despair.

Pre-Dawn Light ▷
The pre-dawn light filtering through a hazy, overcast sky, creates a classic case of flat, diffused light. The illusion of spatial recession is produced by the sequence of tones, from the dark clarity of the nearby rocks to the pale, vague contours of the distant mountains, which diffuse in the haze and drifting clouds. Notice the flat character of the shapes, with little or no distinction between light and shadow planes, and the pale reflections in the water.

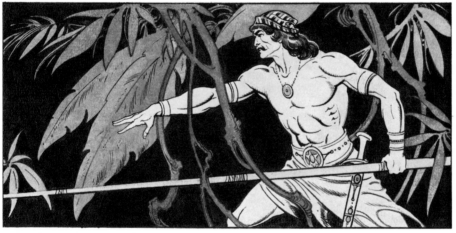

Two-Dimensional Shapes
This drawing contains a series of silhouette-like, two-dimensional shapes in flat, diffused light. Although the contours are clearly defined and the details are drawn precisely, the sense of volume or the third dimension is held to a minimum. Tonal differences alone—the pale tone of the figure, the darker tone of the flora, and the still darker tone of the background—divide the pictorial space into near, intermediate, and far.

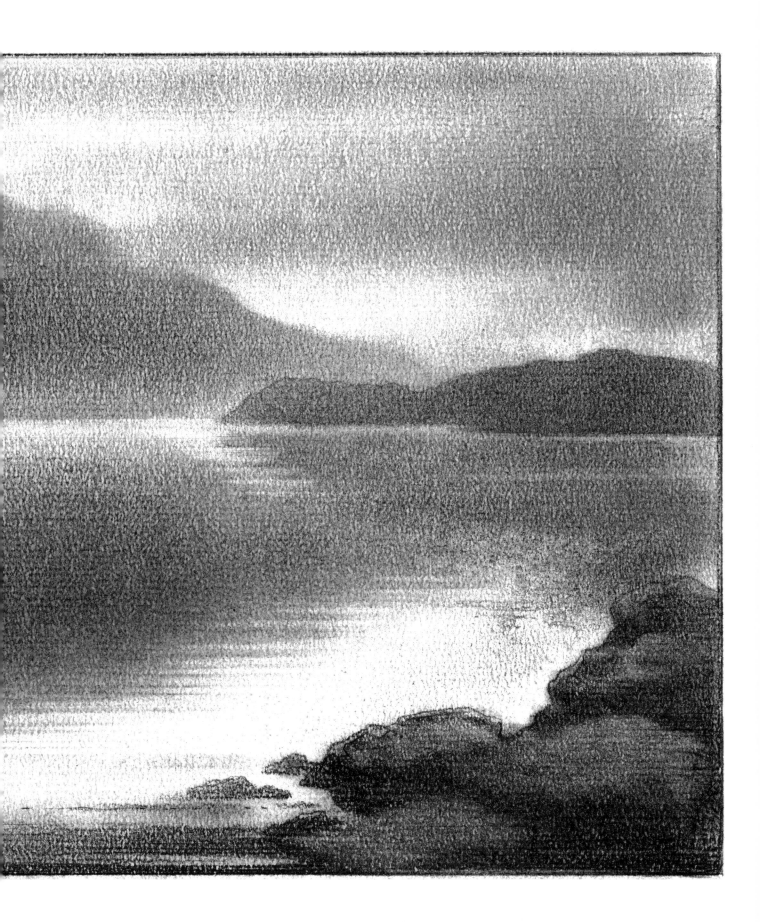

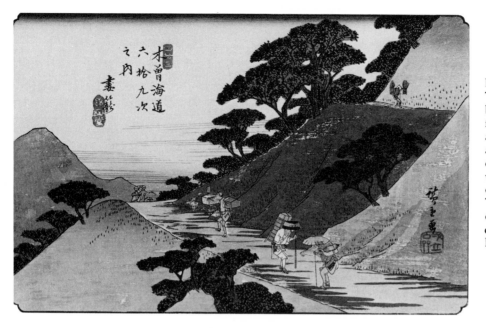

Line and Flat Tone
This Japanese woodblock print by Hiroshige renders flat, diffused light with linear contours and flat colors. The qualities of air and light are rendered without countours, but each form—whether figure or landscape—is enclosed in its specific outline. The ambience is serene and cool, and the image is developed in a series of flat, posterlike shapes.

Subdued Light
In another woodcut by Hiroshige, the fading light is rendered in flat, subdued tones to tell us that the day is coming to a close and the evening is coming on. Like the preceding print, this landscape depends upon the tonalities of flat, patterned, posterlike shapes to tell its story. The mood is communicated by the lightness or density of the flat tones, which are enclosed by precise outlines.

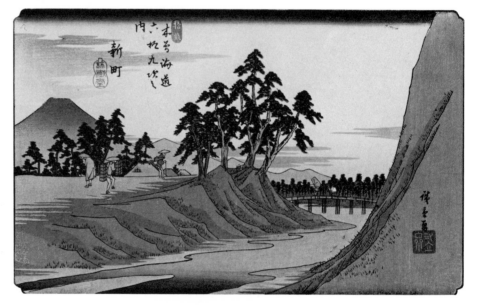

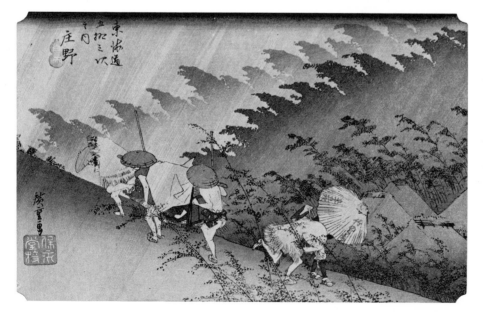

Distance
Still another print by Hiroshige shows how the flat, patterned layers of the landscape create a sense of space. From foreground to distance, the silhouettes of the forms become grayer in the mist, so that the receding tonalities communicate the effect of aerial perspective. This masterwork is an exceptional example of the simplified use of flat, diffused light.

Line Drawing
This line drawing—with dry-brush effects for incidental tone—defines the contours of all the forms to communicate the flat pattern of diffused light. We are aware of a cast shadow here and there, but the contour is pervasive; nowhere does it relax or disappear. There is no tone to suggest depth or spatial recession. We are aware primarily of *shapes.* The drawing depends upon design, so that the eye roams over the surface pattern. This design flow is achieved by visualizing all the elements in flat, diffused light.

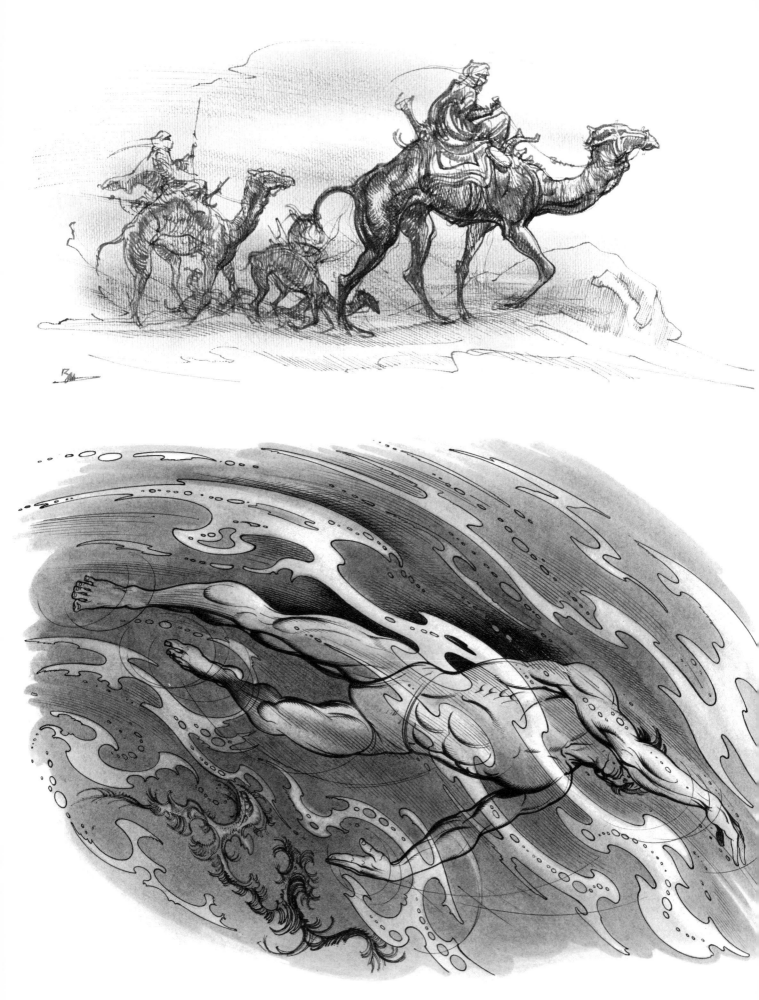

Sandstorm

The camel riders are heading into a blinding sandstorm. It is broad daylight under a cloudless sky, but the sweeping sand begins to blot out all knowledge of the source of the light. Note the difference in values between the foreground and the distance. In the distance, the storm is coming on with a vengeance, and the values are paler. The near riders, drawn with stronger contrasts of tone, have yet to feel the full impact of the storm.

Underwater

Under bright sunshine, water is permeated by light. But, below ten feet, the failing light becomes flat and diffused—a twilight zone that darkens as we go deeper. As the swimmer moves through the turgid, murky water, the light plays on the whorls, air bubbles, and drifting weeds. The flow overrides the figure, which seems to dissolve, appearing and disappearing in the diffused, uncertain light. Notice how the head, lower arm, and other parts of the body tend to flow away into the darkness.

Uneven Light

As we have seen in the preceding example of underwater light, diffused light can be uneven. Such light is still flat in the sense that there remains very little difference between light and shadow. But the tones may vary with the caprice of the atmosphere—or the water. This medieval craftsman sits in a recessed, shady area not illuminated by direct light. The values are generally low in contrast, so that most of the forms of the figure and background seem to melt together. But random patches of light break through from overhead, brightening minor areas on the head, hands, legs, and foreground. At these places, there is marked contrast, suggesting touches of warm sunlight.

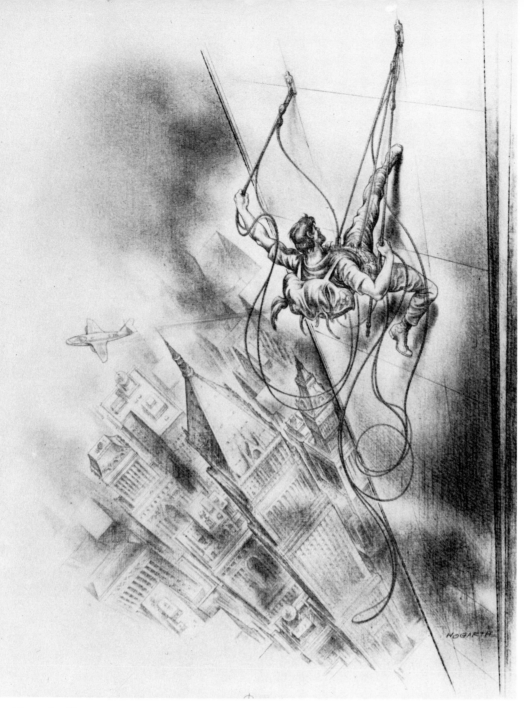

Dust-Laden Air

As a cowhand makes his way across the wasteland, a cold, late afternoon wind blows up dust, sand, and grit. In the dust-laden air, the flat, diffused light becomes uneven. We are aware of form and shadow, but nowhere do we feel the warm effect of strong light or the hard-edged contrast of the shade against the light. Horse and man fight their way into the uncertain gloom.

Above the City

Over a great city of steel and stone, veils of smoke, ash, dust, and pollution block the sun to produce flat, diffused light. Around the daredevil climber, scaling one of the world's tallest buildings in New York City, we see a vaporous mist that obscures the buildings below. The canyons of the city take on an unreal, airy presence, hardly rooted to the ground. The small plane, gliding by for a closer look, is reduced to a ghostly presence in the ephemeral light.

Rain

In the open landscape, the downpour of the cold, sleety rain is already beginning to feel like wet, driving snow. The gusts in the formless darkness tend to obscure and dissolve solid form. The background is swallowed up in the deluge. We see just a few feet ahead. In this turbulent scene, all elements take on flat silhouettes of different values—typical of flat, diffused light.

70

Expressive Light
Cloudy daylight can be an expressive tool, conveying a mood of sadness, alienation, anguish, and dispair. In this figure, the intense head and powerful arm become depressed and pallid in the sallow half-light. The flat, diffused light is the key to the contradictory mood.

Somber Mood
Here the entire figure expresses wretchedness and desolation. There is only one strong contrast—the light on the figure's back against the dark background. The remaining tones are flat and diffused, with the values deepening on the lower forms. The design is circular and convoluted, suggesting that the figure has turned away from the world to an inward retreat. The mood is enhanced by the diffused light, which creates an atmosphere of grief.

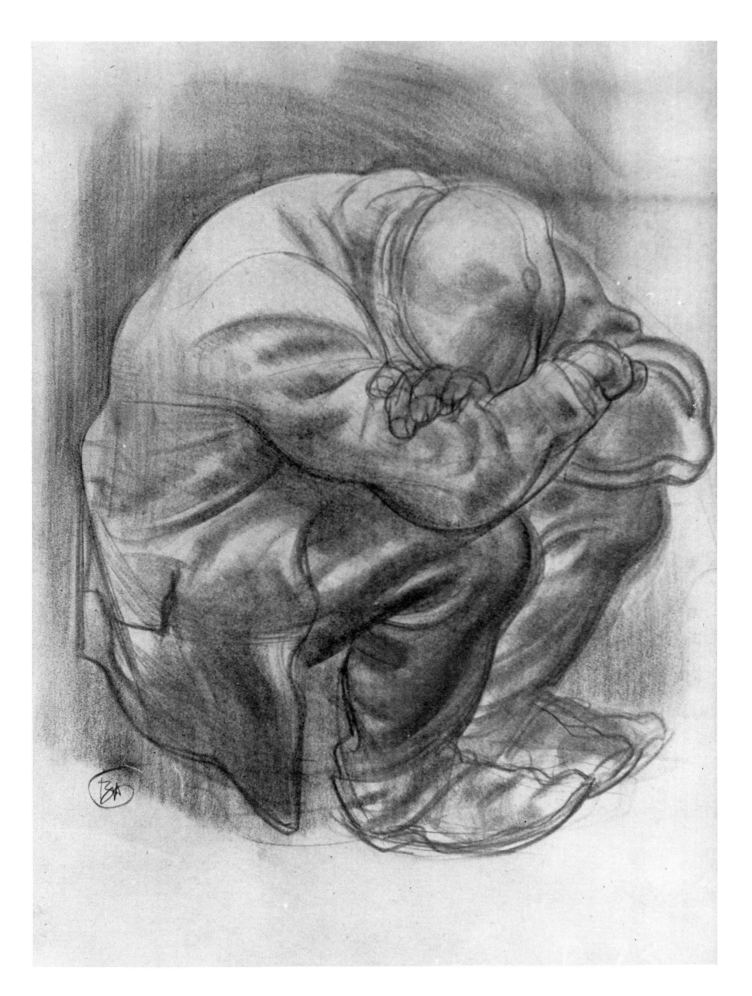

CHAPTER 7
MOONLIGHT

Pale Light, Dark Field

Moonlight is a silvery, pale light in a field of darkness. This dark field is the distinguishing characteristic of moonlight. In a moonlit environment, the volume of darkness is always greater than any area of light. There are large, indeterminate regions of darkness. The moon is a massive reflecting surface for the sun's light. Thus, the moon is not really a direct light source like the hot, yellow-white light of the sun. But because the moon is the only source of light in that dark field, for all practical purposes, we define the moon as a direct light source. As a greatly diminished light source, moonlight tends to produce a range of *restricted light,* usually from a position *high overhead.* Silhouettes are dominant.

Full Moon and Crescent Moon

The silver disk of the full moon is capable of spreading a pale, silvery, bluish light everywhere on the forms of the landscape. But when the moon is reduced to a scimitar-shaped sliver, the available light is dim, indeed, and the landscape is profoundly dark. The full moon is capable of casting shadows. Unlike the shadows cast by the sun, the shadows created by the moon are dark pools with soft edges, and the details on the forms are generally unclear. (Leonardo da Vinci called these smoky-soft tones *sfumato.*) When the environment contains reflecting surfaces, we frequently see double-source light—major and minor light—like that described in Chapter 5, although far less intense.

High Light Source

The high moon illuminates the figure from the rear left. The major light is on the upper horizontal planes of the head and extended forearm. The minor light is on the vertical surfaces. Some large, frontal reflecting surface produces this secondary light on the left side of the chest until the forms bend away into the darkness at the right.

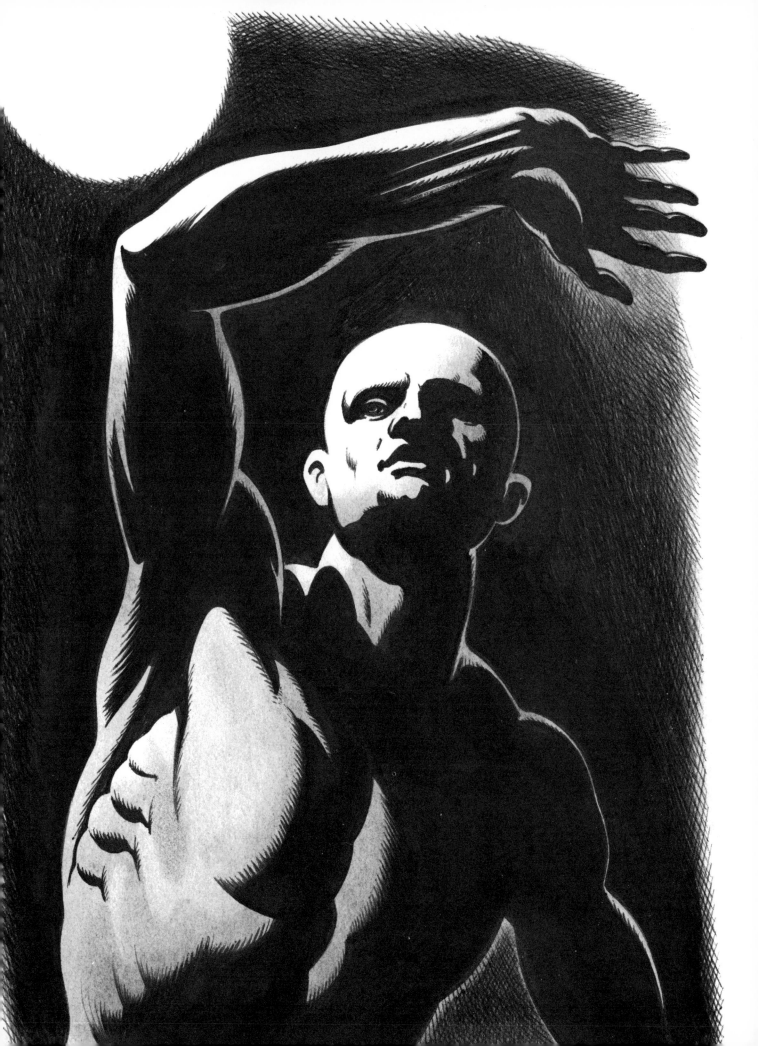

Frontal, Overhead Light
The moon is overhead, striking the front of the figure. The full moon is bright enough to produce cast shadows, which drop from the extended arm to the chest, and from the jaw to the neck. The cast shadow of the torso falls across the extended thigh and obscures most of the arm at the right. Two thirds of the figure is in darkness—a virtual silhouette. The ambience of the night tends to melt the forms into the surrounding darkness.

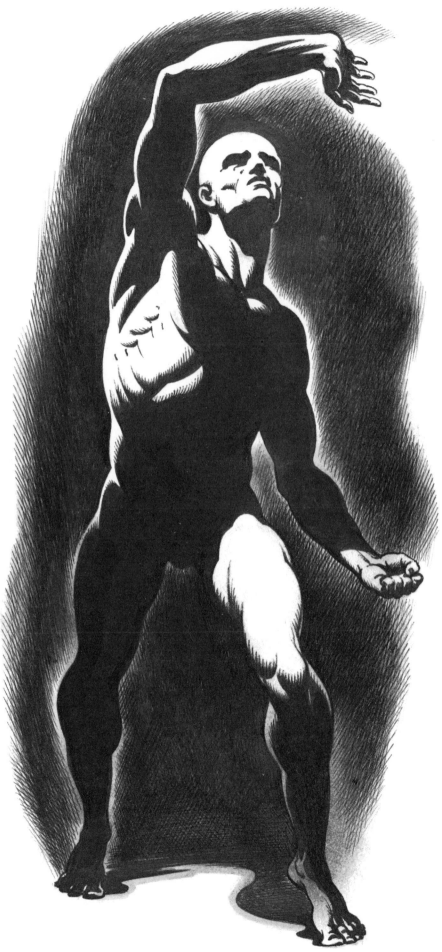

Double-Source Light
This moonlit figure, seen from the rear, is in double-source light. The bright, full moon comes from the right, strikes some reflecting surface on the opposite side, and bounces in from the left to create secondary light on the forms that face away from the moon. Like the figure in the previous drawing, this figure is shown in an open air space, suggesting an uninterrupted, deep void.

Landscape Filled with Moonlight
Night is settling in this Hiroshige wood-cut. The full moon has risen in the sky be-hind the mountain pines, while a mist set-tles into the valley at the right. The light is flat and diffused, as described in Chapter 6. The general tonality of the picture is in a subdued value range that tells us of the oncoming night. The moon lurks behind the trees—which are becoming sil-houettes—and pervades the landscape with its silvery light.

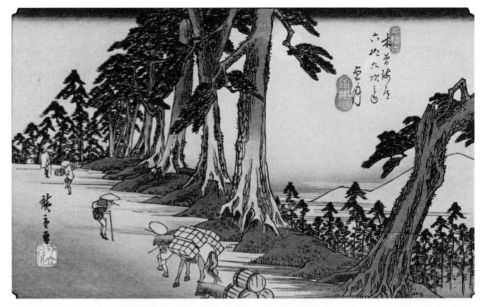

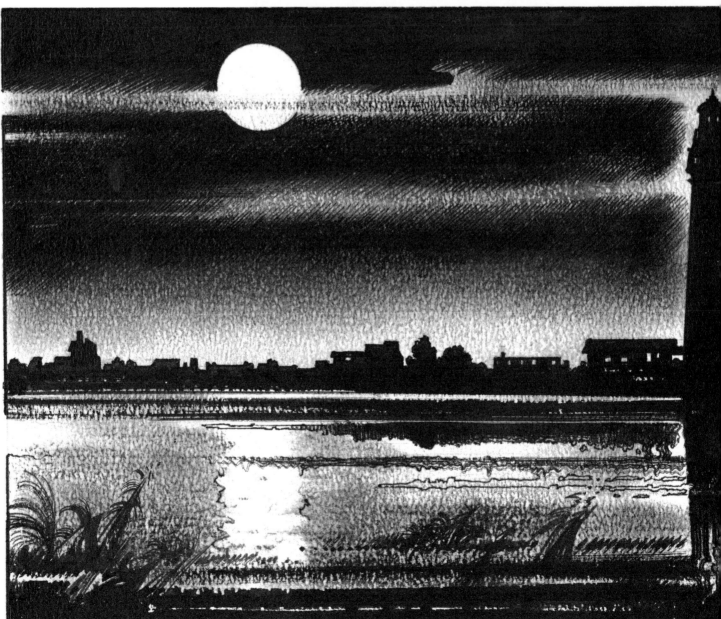

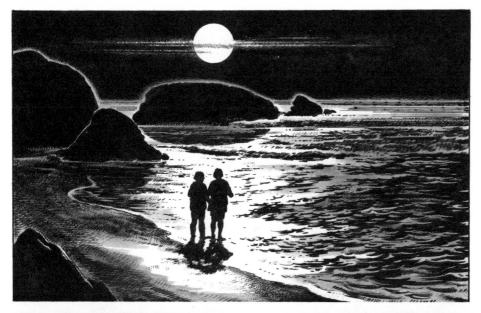

Figures in Moonlit Landscape

Against the brilliance of the moonlit water—under the full, rising moon—the figures are dark, distinct silhouettes. The disturbed surface of the swift water is filled with random reflections of widespread, uneven light. The sharply defined moon throws clear, inverted shadows of the rocks on the water and the figures on the shore. Halations of light bounce from the tops of the rocks in the middle distance, but the nearer rock in the lower left foreground is close enough to let some light define the edge of the form. Looking at the random light on the water, we see that the general direction of the full light is *vertical*, progressing straight down from the moon. Thus, all shadows are directly below the forms. The water darkens to the right and left of the moon's vertical zone of light.

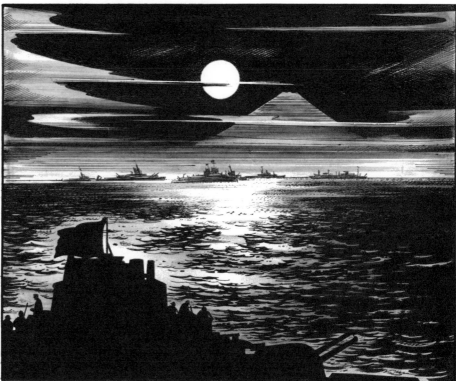

◁ Moonlight and Reflections

The moonlight appears on the water as a light vertical band, while the shadowy reflection of the tower is a vertical band of darkness, directly below the tower. The low-lying houses on the shore also produce shadowy reflections that are aligned vertically with the architectural shapes. You may wonder why the dark shapes of the tower and the houses—as reflected in the water—are all *vertical*, not *diagonal*, even though the only light source, the moon, is at the left. Since regardless of where the light comes from, the reflection is a *mirror image*, vertical reflections are correct.

Scattered Moonlight

When the moonlight is scattered by the cloud streaks, reflections develop over a wide expanse of sea. The brightly lit area of the water is again directly beneath the moon, but there are also lesser lights bounced off the clouds onto the choppy ocean. Between the dark silhouette of the ship in the foreground and the vessels at the horizon, the tones grow gradually paler. The dark sky overhead also grows paler at the distant horizon. The sea and sky are like the two halves of a clamshell, meeting at the distant rim of the horizon.

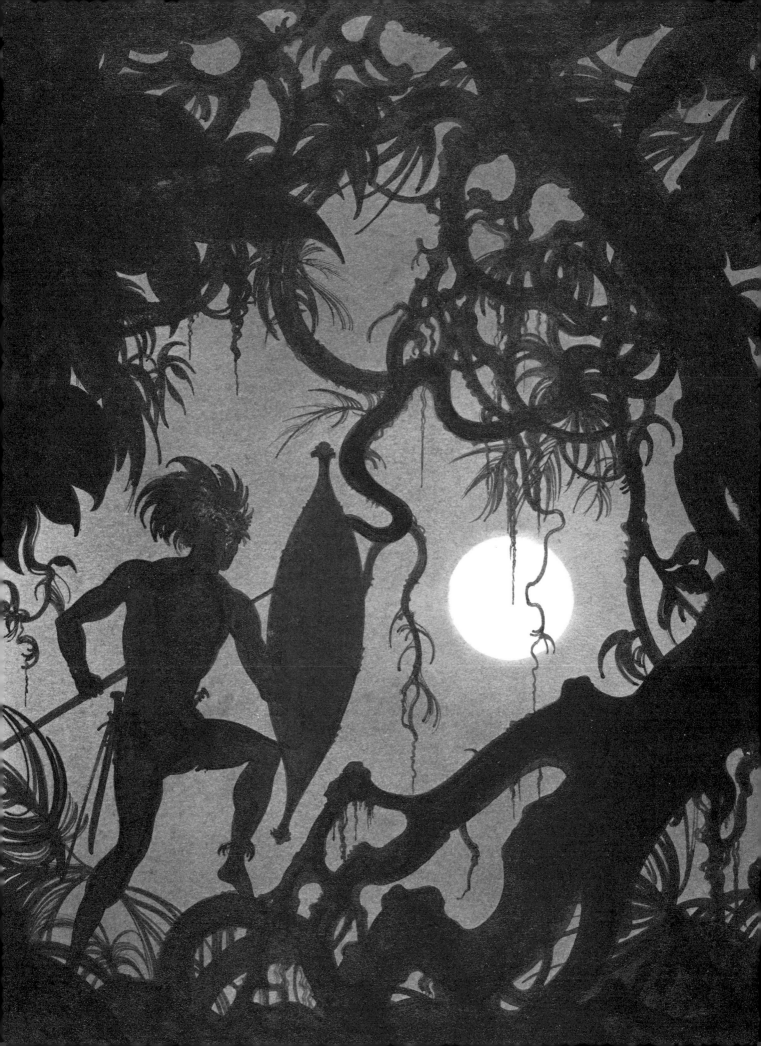

Pure Silhouette

Rising over the jungle, the moon creates a backlight that shows no three-dimensional forms. All the forms—trees, vines, jungle plants, and figure—are pure silhouettes. Yet, flat as the forms are, there is an effect of great depth. One spatial device used here is the overlapping of the vines on the disk of the moon—a signal that "something is in front" and "something is behind." But a greater sense of depth is produced by the three values of the pictorial design: the black foreground detail, the gray sky, and the white moon. The three values suggest the division of space into near, intermediate, and far. Value creates the illusion of space—a phenomenon that you will read more about in later chapters.

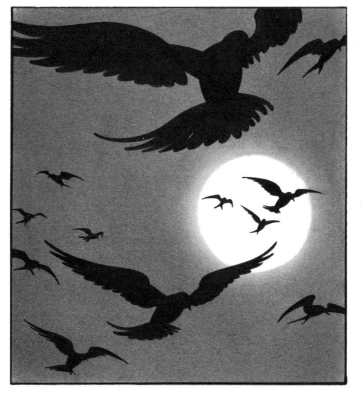

Moon in Mist

The moon is framed by the dark shapes of the sea birds in flight. While the birds have sharp contours, the perimeter of the moon is blurred by the hazy night air. The contrast in contours—between the halated outline of the moon and the precise outlines of the birds—creates an illusion of deep space, enhanced by the diminishing sizes of the birds.

Expressive Moonlight

Moonlight is particularly expressive in images that evoke feelings of romance, mystery, loneliness, terror, or death. Moonlight turns our thoughts inward to the realm of symbolism. In this sketch for a projected painting, the cut stump of a great tree awakens at the onset of energy from the rising moon, which appears through the mist over a desolate landscape. The forms tell us that life will not be denied.

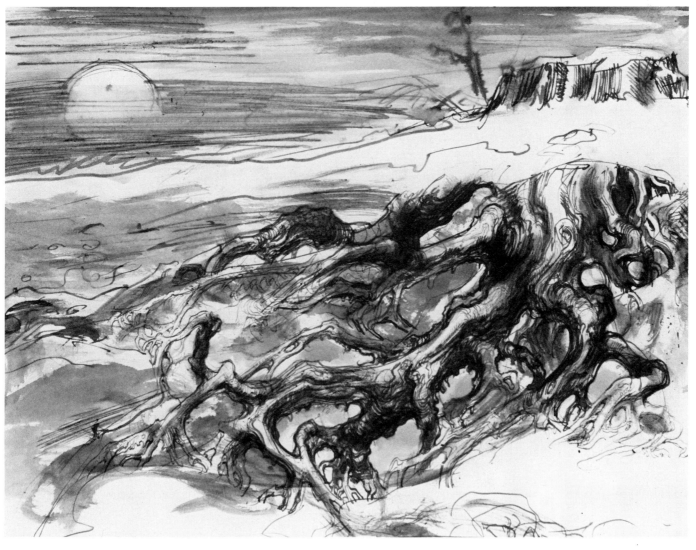

CHAPTER 8
SCULPTURAL LIGHT

Sculptural Light Reveals Form

Sculptural light is concerned primarily with three-dimensional form. Such light alludes to the sense of touch in that we become aware of solid, space-occupying forms in-the-round, forms that we can hold and explore with our fingertips. Thus, sculptural light is often called arbitrary light, universal light, or absolute light because it is an artificial creation—consciously designed to reveal form most effectively, and consciously avoiding the evanescent light effects we normally see. When we draw an object in sculptural light, we imagine an airless space where all forms are clearly seen and all accidental lighting effects are avoided. Such a drawing is no longer a mirror image of nature, but represents an ideal world of pure, unchanging, finite form.

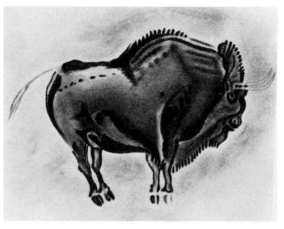

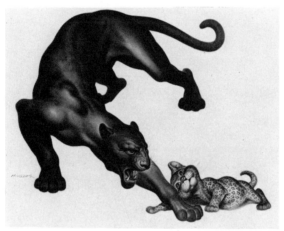

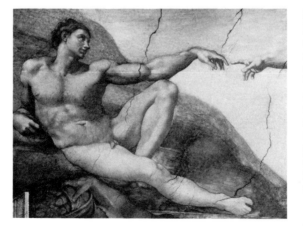

Cave Art

Sculptural or *form light* is as old as art itself. In this prehistoric cave painting from Altamira, in Northern Spain, there is no specific, single light source. Lights and darks are placed where they are needed to reveal the presence of forms and details with maximum clarity. Each form is given a precise identity by careful outlining and toning. Elements are shaped by tones that literally model the forms. See how this is done on the hump, body bulge, and rump.

Modern Poster

This contemporary poster represents the forms of the animals in essentially the same way as the prehistoric cave painting. The contours are clearly stated and easily understood. We can quickly identify every detail—fangs, brow and muscle wrinkles, the highlights on the fangs, even the whiskers. Note how the larger forms—such as legs, shoulder blades, spinal column, tail—are given solid shapes by the advancing and receding light and dark values. As each shape bulges outward, it receives more light; as it curves back, it moves into shadow. See how the *invented* halo of light behind the left ear makes the form easier to read and the spots on the little cub curve with every form.

Renaissance Art

In the figure of Adam from Michelangelo's Sistine Chapel frescoes, sculptural light expresses weight, density, and mass. The contour is clearly defined. Where the center of each form thrusts forward, the form catches the light, as you can see in the chest muscles and the shapes of the legs. Where the edges of the forms turn away, delicate shadows appear. Thus, the shadows follow the outer contours of the forms. This is not a realistic light, but an invented light that is designed to reveal form.

Torso in Sculptural Light

The weight and mass of this torso is the product of sculptural light, which emphasizes bulk and volume. As in the Michelangelo fresco, the bulging centers of the forms receive the strongest light, while the receding edges curve away into shadow. This is not a light effect that we normally see, but a kind of lighting that must be invented or designed by the artist to show each three-dimensional form with the greatest possible clarity and solidity.

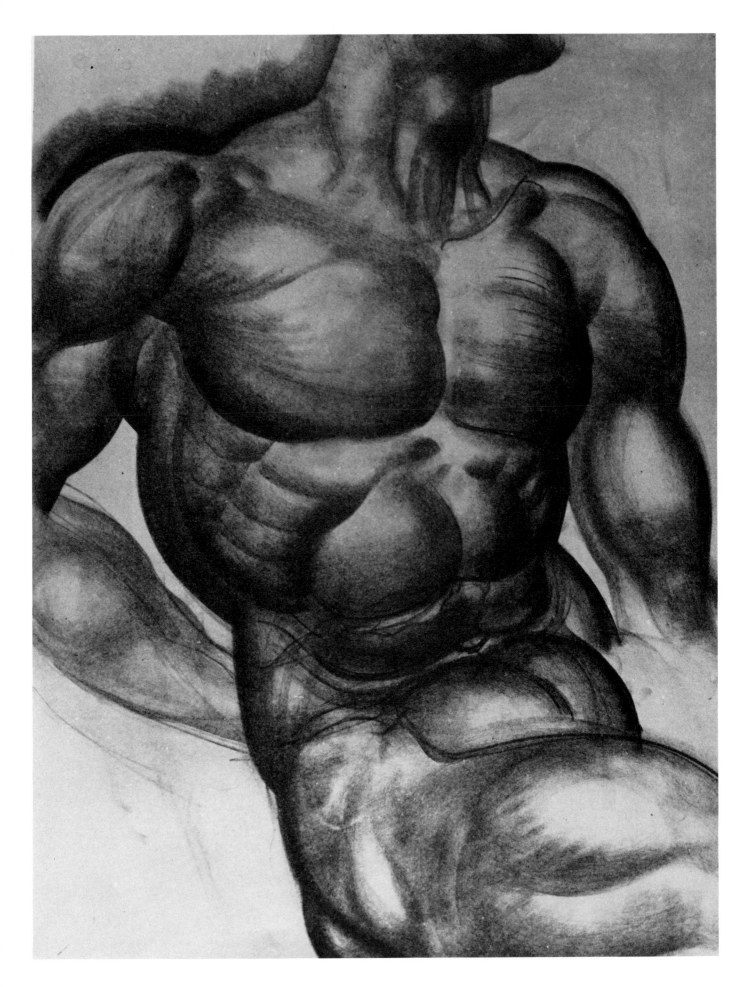

Complete Forms

In this anatomical figure, each form is rendered as a complete entity. Each form can be examined in full detail down to its smallest elements—toenails, fingernails, tendons, and knuckles—which are realized as distinct shapes in the same way as the larger bony eminences and layers of muscle. Like the previous drawing of the leg, the whole figure shows central lights and shadowy edges on all the shapes. Although the effect here is similar to shiny bronze, such lighting does not *have* to look metallic. The following examples will prove otherwise.

Lights Falls on the Center

Each form of this anatomical leg is rendered as if the light falls on the center. The shape of the lighted area is clearly defined, as is the contour of the total form. The darks are laid in at the top and bottom, left and right of the lighted area, traveling around the outer edges of the shape. Let your eye roam over the lower leg and you will see how light and dark meet to make trenchlike borderlines between the forms. These intervals, the lighted centers of the forms, and the tonal dropoff of the dark edges, join forces to produce absolute clarity of form.

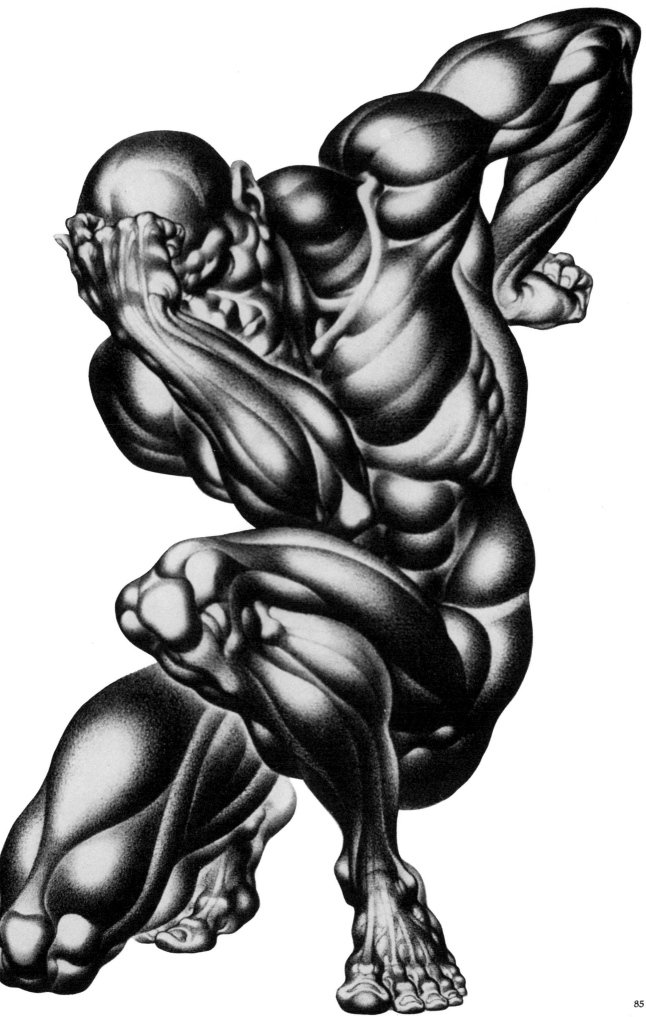

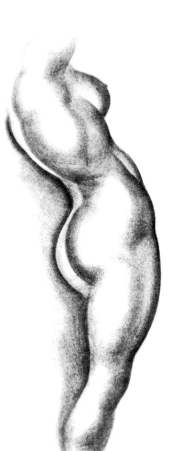

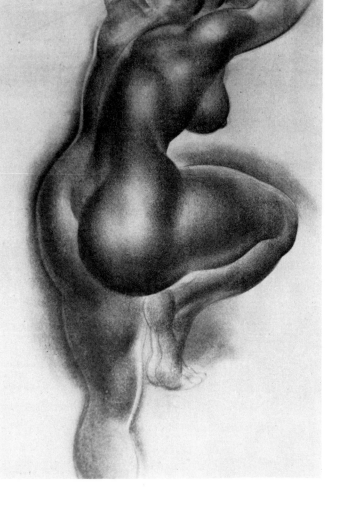

Female Torso in Sculptural Light
The softer forms of the female torso tend to obscure the taut, hard musculature that is more obvious in the previous anatomical drawings. But the sculptural light still records the shapes in the same way. Notice the central lights and edge darks on the breasts and chest forms, the abdomen, and the hips. Even such tenuous and subtle details as tendons and collarbones can be revealed by this pure light.

Form Conceived in Tone
This figure is carried to a greater finish. Once the forms are laid in—as shown in the previous drawing—the broad lay-in and buildup of tones can proceed. The power and solidity of such a drawing is based on the fact that the drawing is conceived in *tone*, not line, so that the shapes can be modeled for the greatest three-dimensional volume. As the subtle, sculptural form emerges, you begin to sense the soft, pliable flesh. The brightly lit center of the hip tells us that this is the nearest frontal form, while the subdued light on the other forms tells us that they all recede inward.

Drawing Method
This simple side-view figure will explain the method of rendering forms in sculptural light. You may, if necessary, begin by sketching the outlines of the forms. (If you like, start by copying this drawing.) With soft chalk, Conté, or compressed charcoal—held so that the side of the stick contacts the paper—lay in large areas with big sweeps of tone. Move the arm rather than the hand, to encourage confident, uninhibited movements. Work around the edges, accenting the outer contours with subtle pressure on the edge of the stick, and leave the lighted centers of the forms untouched. This drawing is not really finished. There is more to do. See how far you can carry it.

No Aerial Perspective

The overlapping forms show us the positions of the shapes in space, starting with the elbow and forearm overlapping the head as the nearest parts of the figure. From here, the thorax, arm, hip mass, and legs are arrayed successively backward in space. But, as the forms claim their positions in space, they do not become lighter or darker; that is, they do not obey the "laws" of aerial perspective, which tell us that forms grow paler and less distinct as they recede. Remember that sculptural light exists in an airless world, an imaginary world without atmosphere, where the air does not intervene to make forms vague as they recede. The illusion of forms in space is created entirely by the overlapping of forms and the rendering of light and shade to create volume—to create forms that we believe we can *touch*.

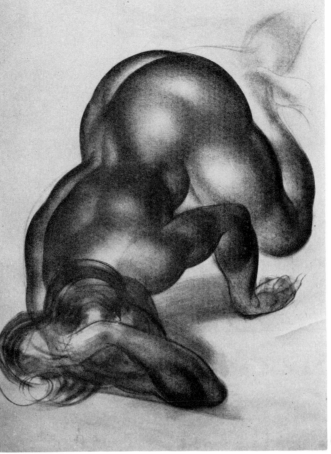

Overlapping Forms

Here is another example of the combination of sculptural light with overlapping forms to create a bold sense of three-dimensional volume. Observe how forms are forced into overlapping positions to enhance what the Italian Renaissance artists called *contrapposto*—the opposition of forms. The background darks are used to elicit contours, instead of suggesting spatial depth.

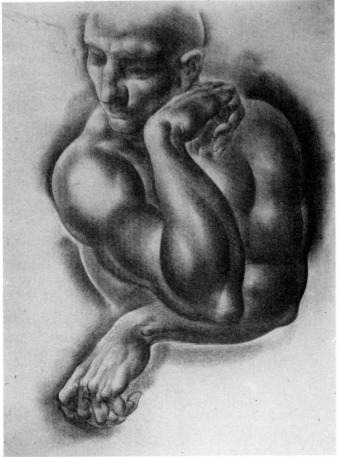

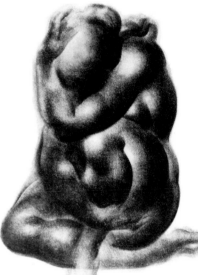

Dense Sculptural Light and Shadow

The dense tonal range exaggerates the sculptural light and gives the figure a monumental sense of volume. This quickly laid-in tonal sketch uses as many arbitrary overlaps as possible to make the forms project and recede. Thus, the figure has the strong tactile feel of a solid form in space.

Bas-Relief Form
The subtle sculptural light on this horse suggests a bas-relief instead of a massive form in the round, yet the same drawing principles are evident. The contours are clearly defined. The convex centers of the forms move forward into the light, while the receding edges turn away into shadow, which follows the contours of the outer edge.

Scribble Drawing
Sculptural light does not always demand a severe, precise drawing style. As this scribble drawing suggests, an expressive, improvised approach is also possible. The direction of the light, striking the full face from a central source, gives the key to all the shadow elements throughout the head. The forms are put in casually. Only a modicum of outline suggests the limits of hair and head. Despite the loose technique, the overall effect is not casual, but thoughtfully designed to create the illusion of sculptural form. Typical of forms in sculptural light, the stubborn nose, and hard-set mouth and jaw protrude into the light, while the receding side of the face turns away into shadow, as do the eyes in their deep, shadowy sockets.

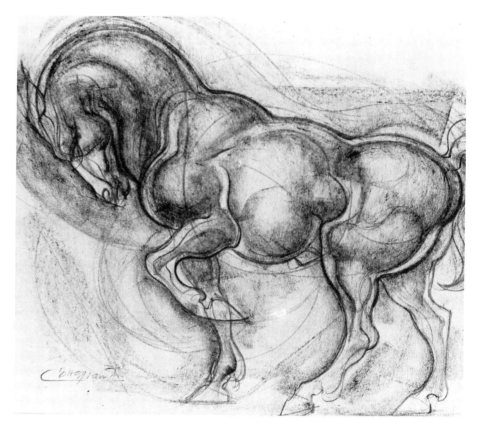

Clearly Defined Forms
In this study of a man from the Gulf of Papua, the pure, sculptural light reveals every detail of the features—the forehead creases, the narrowed eyes, the assertive nose, the protruding lower lip, and the jutting jaw. Equally clear are the artifacts and decorations that give distinction to this proud, dignified warrior. The tones are worked up with multiple, cross-hatched lines that create a full range of tones, surrounded by firm, contoured edges. Each shape, no matter how small, has its own contours and its own gradation from light to shadow.

88

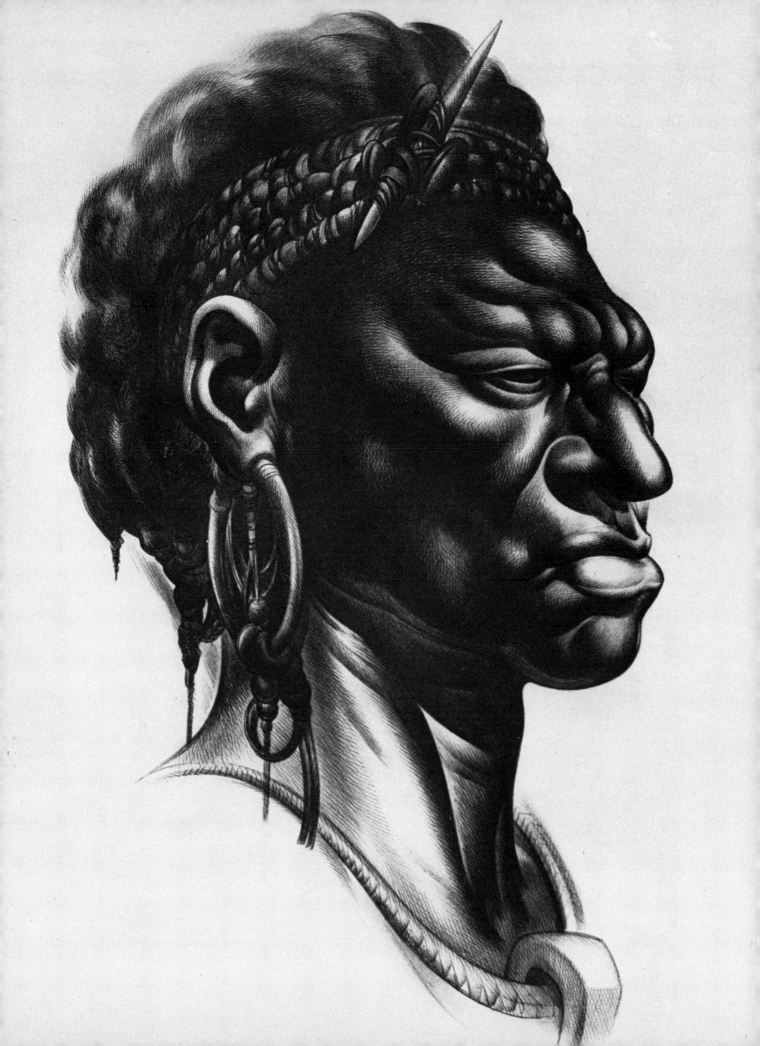

Every Detail Plays Its Part
This poster design of a bullfighter, driving
home his sword between the shoulders of
a charging bull, exploits the clarity of
sculptural light to create a sense of tension
and danger. The light reveals every detail,
every form, so that all essential elements
are visible. The dark mass of the animal
with its muscular forms; the eye of the
bull under the cape; the hair at the tip of
the tail; the matador's "suit of lights" with
its agitated play of creases; his tense hand,
determined face, and slick hair; even the
bows on the slippers, the shiny sash at the
waist, the shoulder tassels, the pointed
barbs—all are shown in sharp focus. If you
care for drama revealed in precise detail,
this is the light to use.

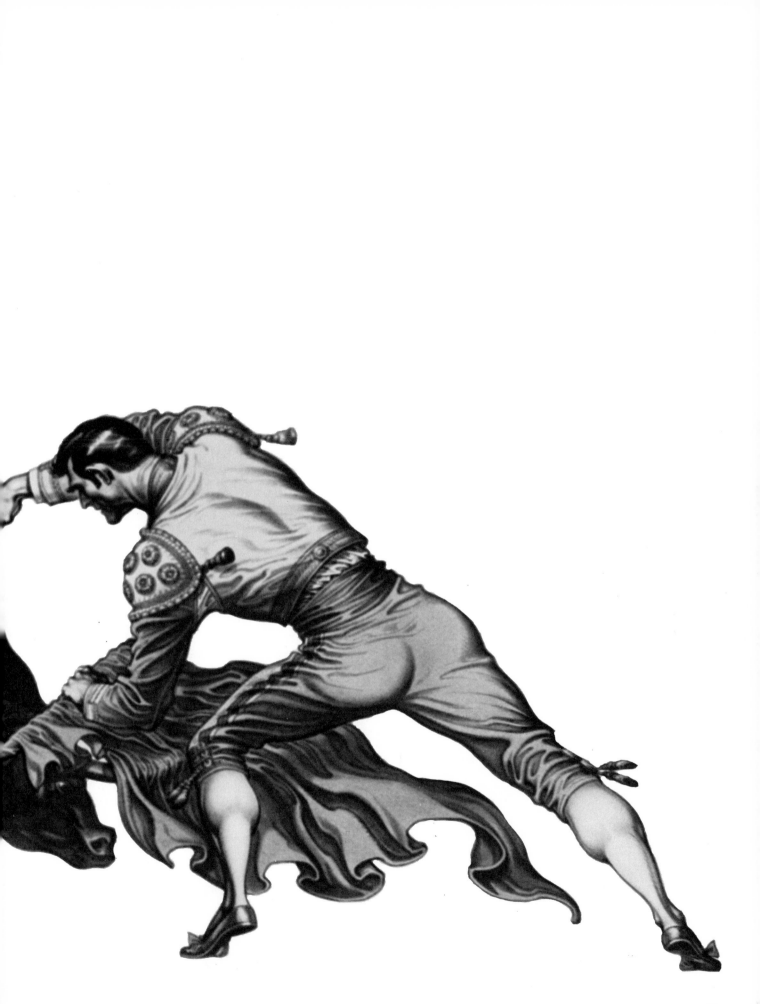

SPATIAL LIGHT

Values Create Space

We know that perspective is essential in conveying the illusion of three-dimensionality within the picture plane. But by organizing the objects within the picture into a carefully worked out system of values, the artist can make the relative lightness and darkness of objects lead the eye in and out of the picture, suggesting space and communicating near and far distances. This schema of values is based on a rational and logical system which I define as *spatial light*. Spatial light can create a sense of distance, move the eye into and around the picture to create a visual focus and force the eye to concentrate on a given place within the picture plane, sometimes called the *center of interest* or *area of dominant impact*.

Phototropic Principle

The principle of spatial light is based on the fact that the eye is phototropic—that it will always seek out and focus on the *lightest* area in a picture, which represents the brightest value. This is typical of the way our eye focuses on real objects—in that we tend to be attracted to the most brilliantly lit areas of a scene—and it is also the way we respond in a realistic drawing. So if there is a light form in the foreground of a drawing and the area behind it is a darker tone, the dark-toned area will become a receding background plane in our minds. The net effect of the dark background, then, is to force the light form forward. But if the situation were reversed and the lit object were in the background while the foreground forms were dark, the effect of this distant light would be to lead us *back* into the pictorial space.

Figures in Interior: First Version ▽

This interior with figures is clearly divided into foreground, middleground, and background. You will see this picture in three different versions, all identical except for the disposition of values—and the shifts in spatial focus that will be created by those changes in value. In this first version, because brightest light is on the nearest figure, the light focuses your attention on the foreground. Other areas recede because they are toned with darker values. The result is an outward movement from back to front, created by the concentration of the bright light in the foreground. The diminishing size of the figures has nothing to do with where the eye focuses in the pictorial space. Spatial focus is defined only by the light.

Figures in Interior: Second Version
The pictorial elements are the same as in the first version, but there is now a radical shift of interest to the background, where the light is now illuminating the personnel who scan their computer screens. The rest of the picture is in black and a medium gray. Again this proves that the eye is drawn to the light, no matter where that light may be and regardless of the subject or the narrative. The placement of the light can be arbitrary as long as it has optical appeal and as long as the eye finds it convincing. *What the eye accepts as logical is pictorially permissible.*

Figures in Interior: Third Version
Now the light shifts to the seated man in the middleground. All other elements in the picture are black and medium gray. The eye moves inward and outward, locating the bright light in a central position between the extremes of near and far. To test the force of these three light positions, turn the three pictures upside down and look at them again. When the subject matter no longer interferes, the shifts of the lighted areas—and their magnetic effect on the eye—will become more evident.

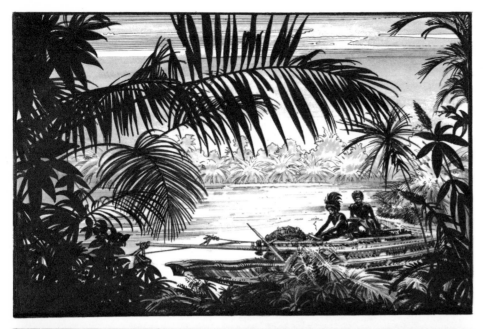

Light in the Foreground
In this jungle setting, the emphasis is on the boatmen who sit in a patch of light at the river bank. This result is reinforced by the dark silhouette of the foliage that frames the immediate foreground. Across the water, the opposite shore and sky are held to an overall medium gray tone. The eye is attracted to the foreground, seeking the region of strongest light.

Light in the Near Middleground
In this night scene of a village celebration, the eye is drawn to the near middleground. Surrounded by the darks of the foreground building and lesser architectural structures in the distance, a bright bar of light sweeps across the middleground, moving across the plaza, rising on the celebrants, and then bouncing up to the front and back of the tower. Everything else in the picture is reduced in value. This picture also shows that the spatial light does not necessarily have to be located on the ground, but can move vertically as well as horizontally.

Light in the Middleground
The light divides this pictorial space virtually in the middle. In the shallow space of the entrance to the stable, a central light from an unseen high source drops midway into the interior, falling on the man and the horse. All other pictorial elements are held to reduced, dark values. The eye focuses on the middle distance. The spotlight effect carries the eye to the center of interest like an arrow to a bull's-eye.

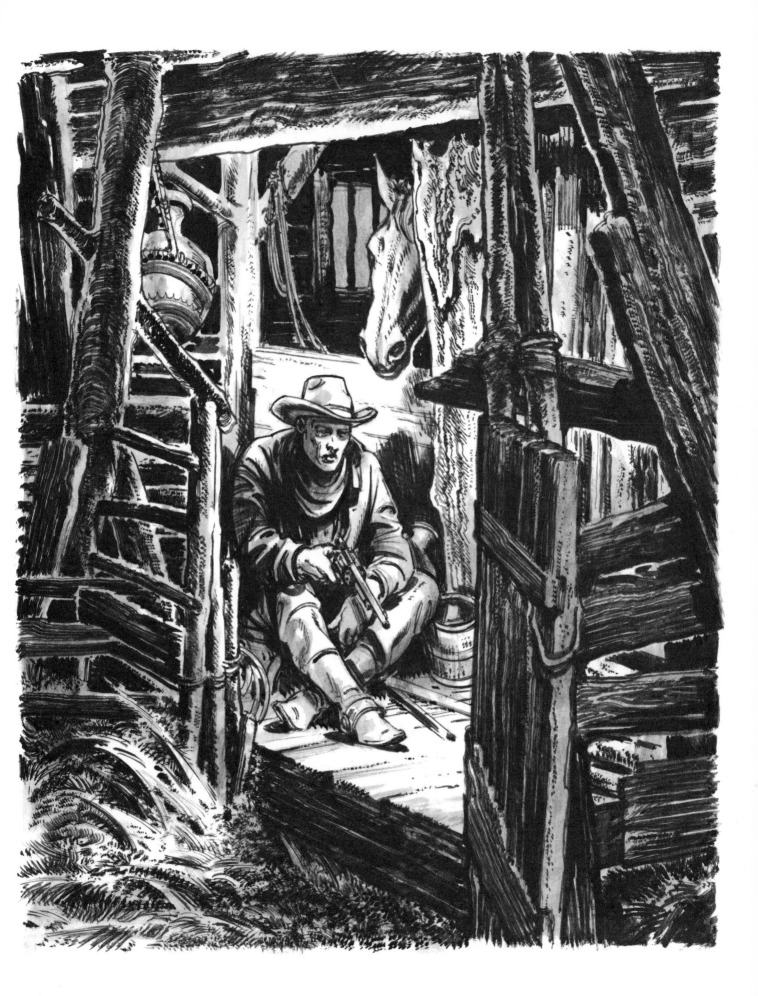

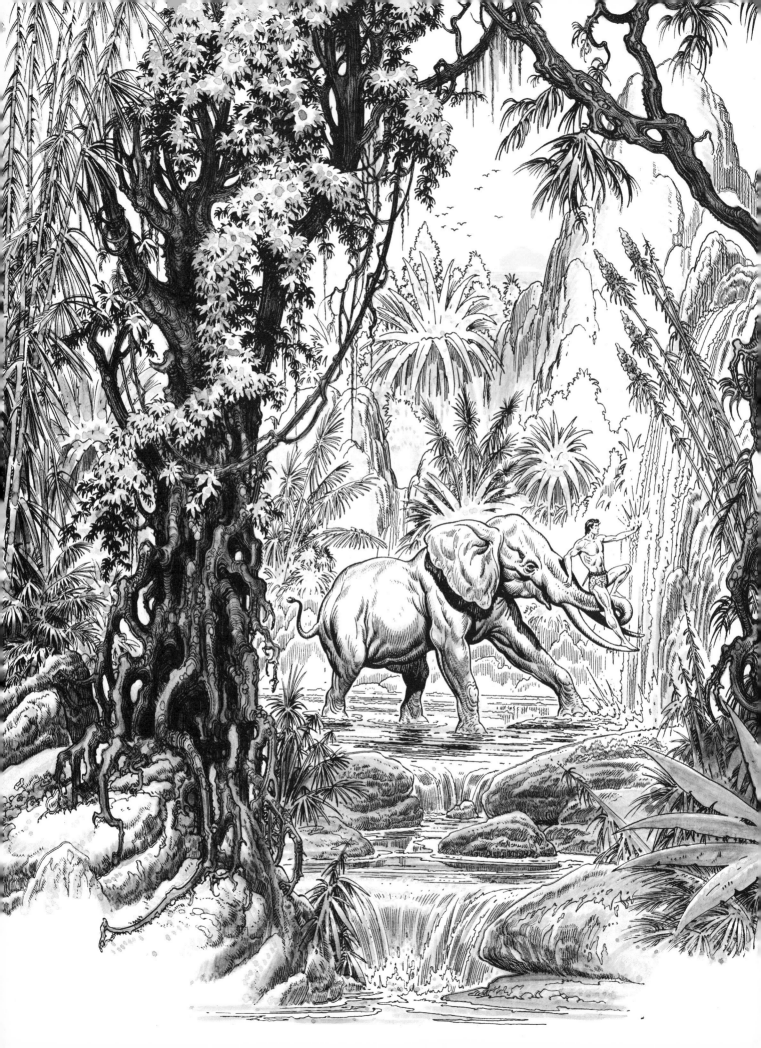

◁ Landscape with Light in Middleground

In another version of the bull's-eye design, the light carries the eye to the middle distance, where the action occurs. The lighted middleground is framed by the darker foreground tones of the trees, vines, jungle verdure, rocks, and water. The subdued values of the background force the eye forward into the lighter midregion. The spatial light is less obvious, more delicate and discrete.

Light Past the Middleground

Now the focus of the light is past the midpoint of the pictorial space. The fisherman casts his line in shallow waters as twilight settles, and the dim light sends dappled reflections across the surface. The rocks and water in the immediate foreground are already darkening into dusk. Farther back, the light surrounds the fisherman. In the distance, the reduced values convey a misty, vaporous sky above an unclear horizon. The eye moves past the darkening waters to focus just beyond the center.

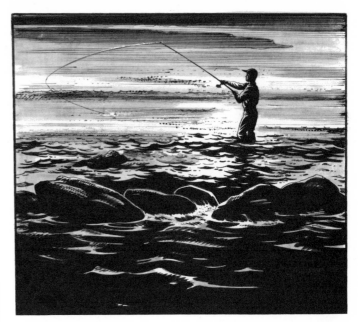

Light in the Background

The eye moves into the picture as the spatial light focuses our attention on the background. The foreground is held to black and medium gray on the warrior and the surrounding rocks. The thrust of the eye is to the rear, where we focus on the distant cliff and the curling smoke. This rear space is the lightest value and the center of visual interest. The pictorial design reinforces the inward movement of the eye: notice the angular thrusts of the spear, the sword, and the folds of the cape, all carrying the eye to the right rear.

Light in the Remote Distance

A brilliant patch of moonlight on the still water draws the eye to the far horizon. The eye is drawn inward—through the dark foreground—by the bright light in the distance. The design of the pictorial space is like a tunnel: the shapes of the foreground tree and rocks create an elliptical passage that carries the eye to the rear light. Thus, the light becomes a target—like the bull's-eye effect of previous examples. Notice how the alternating black and gray bars in the middleground slow the eye as it moves toward the background light. Without these bars, the deep space would shorten and collapse.

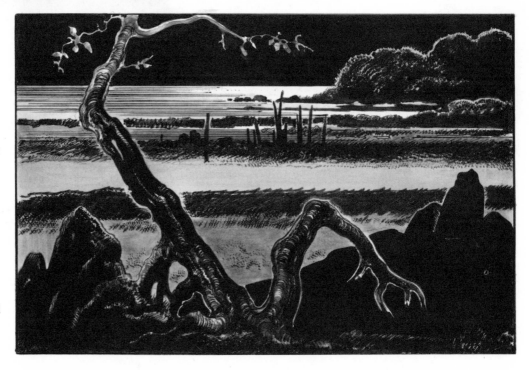

CHAPTER 10
ENVIRONMENTAL LIGHT

Environmental Light Is Circumstantial
Thus far, you have seen special kinds of light—such as single and double-source light, flat light, and moonlight—that are determined by limited causal factors, such as the source and direction of the light. But environmental light is not a specific kind of light, but is the product of atmospheric *circumstances* such as warm and cold, or wet and dry weather. Environmental light also reflects the time of day (sunrise, sunset, nightfall, moonrise) and even the time of year (spring, summer, fall, and winter).

Varieties of Environmental Light
Environmental light encompasses not only visual effects, but sensual modes and feelings. Images of environmental light can convey balminess and lambent warmth; cold rain or frigid drizzle; blustery snow and icy wind; rain, murk, and night wind; and twilight afterglow or overcast gloom. Such images can also capture the atmosphere of varied locales such as grassland, woodland, mountain, valley, forest, and tropical or arid places. In short, environmental light evokes time, place, and atmosphere.

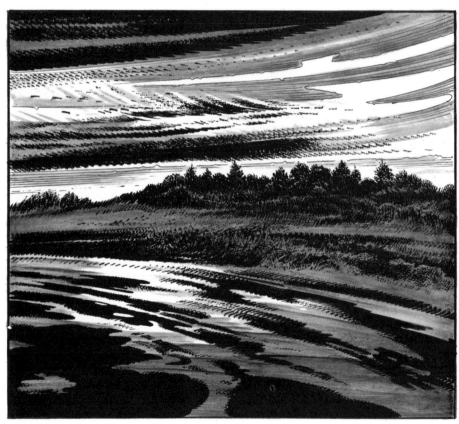

Dawn
Over the scrubby growth, dawn appears and lights up a fast-disappearing, overcast sky. Dark night clouds are scudding away. From behind the clouds, a pale, rosy light reaches across the streaked formations in the sky. In the foreground, a broad stretch of mud flats, flanked by weeds and grass, reflects the oncoming light, heralding the approach of a cool, bright, early summer day. Notice how the dark band of the land area is isolated by intermittent bars of gleaming light, above and below.

Mist

Early morning mist stirs from a ravine and begins to drift as the warming air rises. Streaks of mist emerge and float away in shredded layers. The sun has not yet appeared over the craggy pinnacles of eroded sandstone, but the thermal air-flow already begins to dissipate the misty atmosphere that shrouds and softens the distant shapes of the landscape.

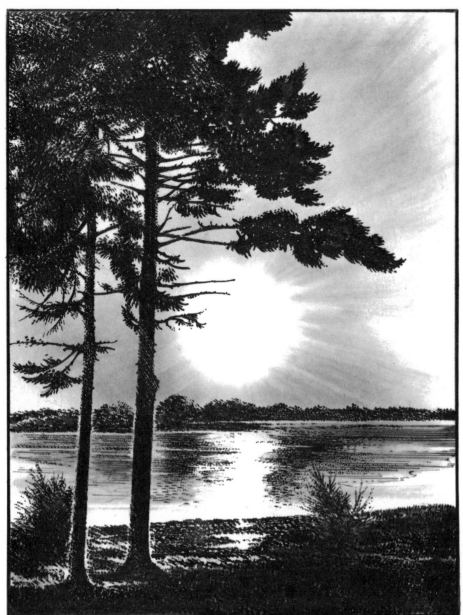

Morning Sun

The midsummer morning sun rises over a reservoir lake surrounded by scrub pine, shrubs, and stunted undergrowth. It is the beginning of a hot, humid day. The ground is parched. There has been no rain and there is no rain to come. The sky has been cloudless for a fortnight. The sun penetrates the haze, burning through the moist air with stabbing rays that radiate in all directions like subtle spokes. On this bright, sunny day, the entire picture is constructed with dark silhouettes—from foreground to distant background—supported by a hazy sky, toned gray and streaked with white. Just three values—black, gray, and white—express the hot, clammy light.

Midday in Midwinter

Cool, bright contrasts appear under the clear sky of a midwinter day. Clear air and flat light display every detail in sharp relief against the snow-carpeted whiteness of the land; brittle grasses, denuded saplings, scattered evergreens, even the faltering stream that threads its uncertain way down the gentle slope. Beneath the larger undergrowth we see pale shadows, but they are largely overruled by the darker tones of the big trees and the stream. White snow and clear, wintry air reveal every element in the landscape with singular contrast and clarity.

Coastal Fog

A bank of fog shrouds the seacoast with dense, misty atmosphere. It is midmorning, but the summer sun has difficulty dissolving the mantle of fog that sweeps in from the sea. Some light works through and glows dully in the air and on the water. The light also finds its way through places of lesser density—around the sailboat, for example—and a patch of light, higher in the sky, heralds a clear day later. The rocks close to shore have some weight, some connection with the laws of gravity, but the boat and the distant sea seem to be lost in a misty, nongravitational space. This effect is produced by the falloff of values from the dark, fairly distinct rocky foreground to the uncertain, unclear background, which suggests a deep, endless space.

Winter Gloom △

Here is another vision of winter that is quite different from the Japanese mode. It is afternoon among a grove of trees that have been lightly dusted with snow. The wind is bringing heavy clouds and damp, cold air, presaging more snow. The murky sky, streaked and ominous, settles close to the ground and darkens the background with a cheerless pall. The white snow is caught on twigs, branches, and bark. Compare the bone-chilling atmosphere of this drawing with the Japanese winter of Koryusai. The Japanese woodcut is pleasant and soothing, detached and aloof, appealing to the mind, awakening a tranquil mood of meditation and contemplative enjoyment, while the drawing evokes cold gloom.

Snow in Flat, Diffused Light

Gentle snow is falling as a lady readies herself, with the aid of a servant, for a walk in snow that is already deep on the ground. The sky is overcast. In the flat, diffused, gray light, heavy flakes course downward through the still air. The diffused light tends to emphasize the contours, patterns, and flat shapes of the figures. Such light diminishes three-dimensional form—eliminating cast shadows because there is no specific light source—and reduces objects to flat, two-dimensional configurations. Thus, both the ground and the sky are flat shapes, the same tone from front to back, with no value changes to indicate depth. The woodcut is by the Japanese master, Koryusai.

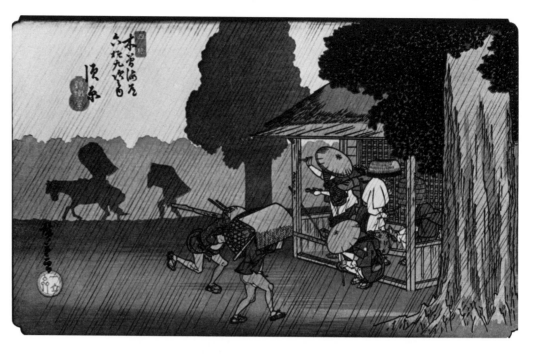

Dust and Wind ▽
A late afternoon wind sweeps
dust and sand over the parched
ground. The weather is hot and
dry, without rain. A shore bird
waits for the air to settle before
flying off to seek food. Com-
pare the dense, dusty atmos-
phere just above the ground
with the lighter, uneven tone
higher up. The wayward
branches and twigs respond to
the random thrusts of the
winds. The sweeps of tone in
the sky convey the raw look of
tumult and turbulence.

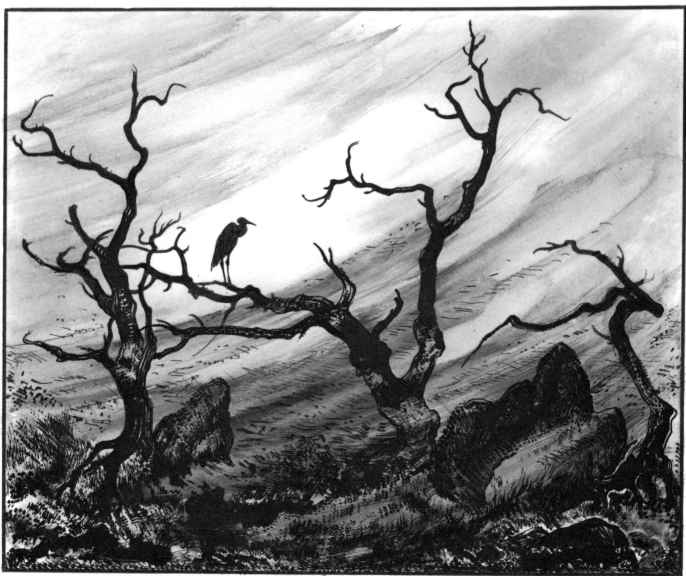

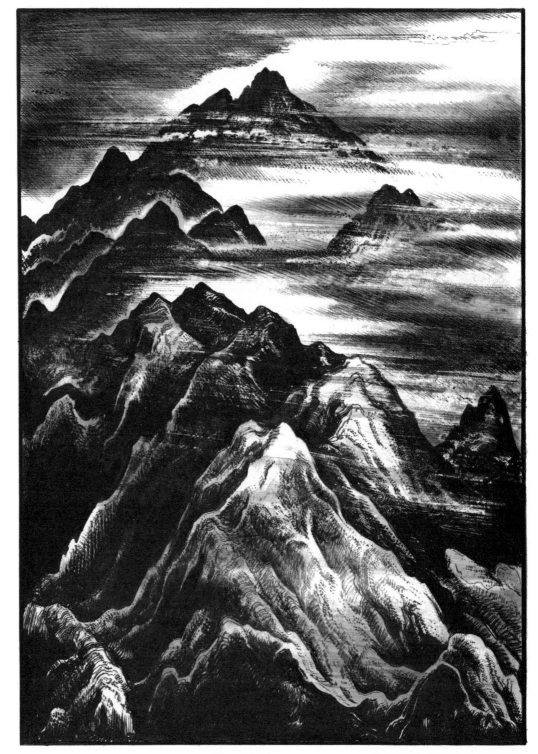

◁ Rain

Late in the day, the pelting rain has interrupted all activity and everyone runs for shelter except the hapless wayfarers silhouetted in the distance, who apparently have no choice but to continue their plodding way. The Japanese master of the color woodcut, Hiroshige, gives us a rain-soaked, overcast landscape with two distinct aspects of flat light. First, despite the rain, the flat light leaves the rainy foreground transparent so we can see every detail: the tree, figures, baskets, straw mats, thatched roof, and so on. In the background, however, all detail is lost. The dense, rainy air reduces the plodding travelers and the tree at the center to gray silhouettes. The mass of trees at the far horizon is nothing more than a contour line that encloses a lighter gray. The rain streaks are all the same thickness, but Hiroshige leaves just a bit more space between the streaks in the foreground.

Fading Daylight

Late in the day, the arid, craggy peaks begin to sink into the gloom of the receding daylight. The air is cooling rapidly and a swift wind sweeps clouds over the mountains. In the distance, the peaks break through a tenuous sea of mist. In the foreground, the mist has not yet obscured the fading light; we can still see creeping shadows on the steep-walled valleys and depressions in the slopes. The light seems to come from three sources: from the right, intermittent, oblique sun comes through the cloud rifts; on the left, a more delicate light feeds into the edges of the forms; and from above and to the rear, the wind-driven mists and clouds seem to glow with diffused light.

Icy Atmosphere

Among these Antarctic icebergs, full summer daylight is past and the season is slowly changing. The forms are struck horizontally from the right by the low, brilliant sun before it sinks below the horizon. The clear air and unimpeded light create sharp contrasts between the illuminated icy surfaces and the correspondingly deep shadows. In the uneven foreground, the surface ice reflects the light and also shows dark patches of open sea. A cold light permeates the low horizon. High above, the transparent but deepening sky shows a vague, spectral, crystalline light.

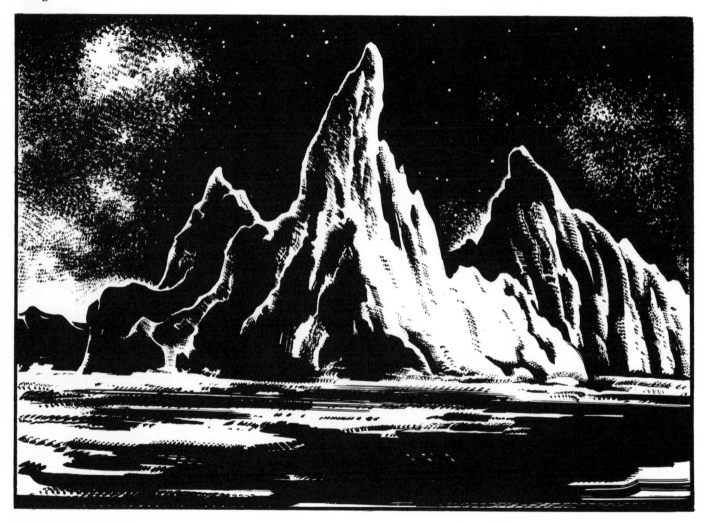

Twilight

Reflecting on the shimmering river at the end of a summer day, the setting sun sifts through the spidery network of the bridge. The sky is ablaze with serrated lights, which are mirrored on the water.

Storm

As dusk comes on, the mountains and foothills are beset by a sudden storm of rain and wind, swept in with the massive clouds. The landscape is enveloped with darkness, while an uncertain, flickering light hovers over the brows of the mountainous shapes. The origin of the light lies far beyond the shapes at the horizon, but the rolling mass of clouds and vaporous air reflects the light in every direction, producing an unearthly display of illumination on the landscape.

Snow and Rain

On a winter evening, darkness has fallen early, as wet snow, laced with cold rain, builds up on every surface. People huddle under a shelter, facing a city street and a construction site, and wait for a bus. The snow is drawn in small, rough strokes, so that it looks grainy. The snow mingles with dull, whitish reflections and light halations on all the structures beyond the foreground. A sense of deep space is created by the contrast between the dark foreground silhouettes and the snowy area beyond. The streaks of falling rain and snow are put in with a single-edge razor blade, stroked diagonally upward against the grain of the drawing paper.

Nightfall at Sea
At nightfall, the rising wave is lashed by a stiff wind that brings gusts of heavy rain streaking across the dark. Spume and spray tear loose from the crests of the waves. Icy sleet bears down at a steep angle into the water. The foam and the aerated, churning water create trails of light on the pyramidal wave forms and on the wind-driven swells.

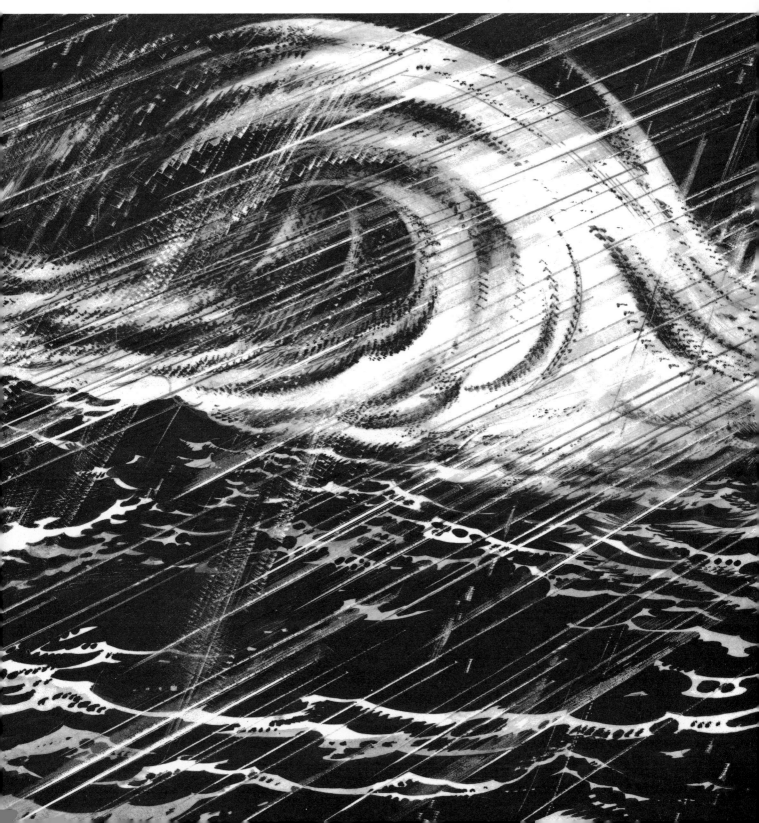

Calm, Moonlit Sea

The silver moon reflects on the calm waters of the sparkling, tropical sea. It is a balmy night of velvet blackness. Large areas of dark are set against lesser areas of light. There is just enough light to show the sailboat, the gently lapping waves, and the limitless, beckoning horizon. The design of curves against horizontals reinforces a sense of rest, relaxation, and sleep.

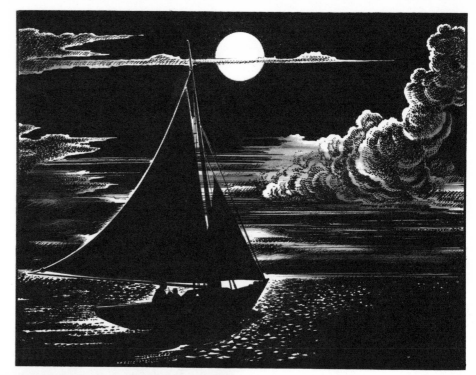

Underwater Light

As the scuba diver moves through the coral colonies and exotic marine life, a burst of light opens a cavernous space in the darkness. The light comes from above the surface of the water, gradually fading into the mysterious darkness as tiny, ghostlike fish follow the strange silhouette of the diver through the deep, with his trailing, silvery plume.

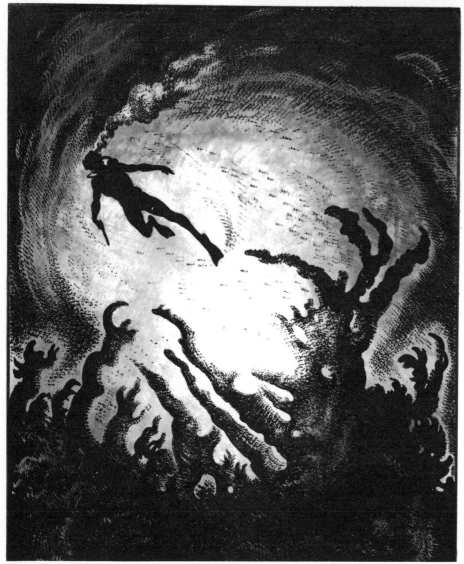

Light in Outer Space

Illustrator Jerry Robinson contributed this drawing of space vehicles in the unbounded void of eternal night. Light falls on the near vehicles from the sun. The moon wears a circular halo of backlight, no doubt from the sun as well. The dark sky is dotted with the light of the stars. The sky itself contains no light, no gravity, no movement, no atmosphere—only timeless darkness.

CHAPTER 11
TEXTURAL LIGHT

**Textural Light
Reveals Surfaces**
Just as sculptural light reveals
three-dimensional form, tex-
tural light reveals the surface
qualities of these forms. Tex-
tural light suggests direct phys-
ical contact, as though the eye
were a tactile organ—scanning,
testing, and probing surface
phenomena like a fingertip. But
because the eye can explore
more of the environment than
a fingertip can reach, we can
perceive the effects of textural
light both close up and at a
great distance. That is, we can
examine the texture of a small
object within arm's reach, and
we can also see the texture of a
distant landscape.

Western Landscape
Illustrator H. M. Stoops lets the
hard, bright sun reveal the
massive textural detail of the
striated cliffs. Here, the textural
light creates strong contrasts
between light and shadow—
with the detail in the shadows.
This is equally true of the great
upthrust cliffs of shelved sand-
stone and the rocky debris be-
low, whose texture is revealed
by tiny touches of strong
shadow.

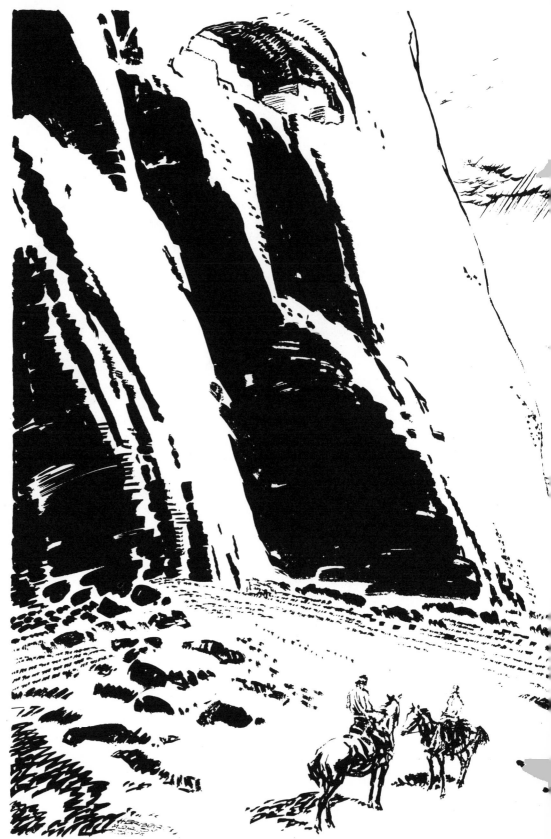

Rough Bark

The bark of this desert tree branch shows serried striations that appear to move, twist, and writhe like some strange creature. The texture is quite varied: the bark is hard, rough, and dry; the branches are sharp; and the springy endgrowths look like the bushy tails of small animals. The light emphasizes the texture by catching all the high points of the form, while all the low points—even the tiniest crack—sink into shadow.

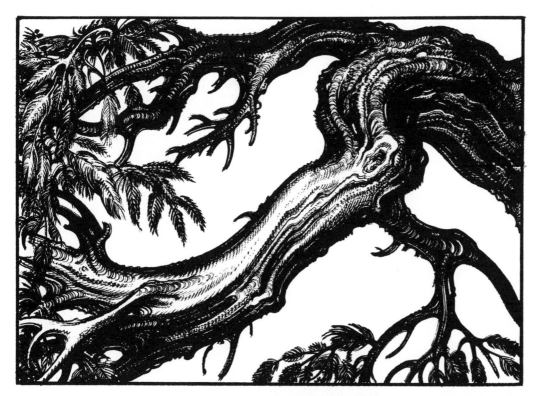

Parched Ground

The dry, gritty surface of the ground exposes sparse, granular topsoil, coarse sand, and gravel interspersed with stones and layered rocks. The shadows are rendered as clusters of tiny, dark flecks that allow other flecks of light to shine through—as if the picture consisted of granules of light and shadow. Thus, the light and the drawing technique convey a tactile feeling, as if your fingertip were exploring the grainy surface of the land.

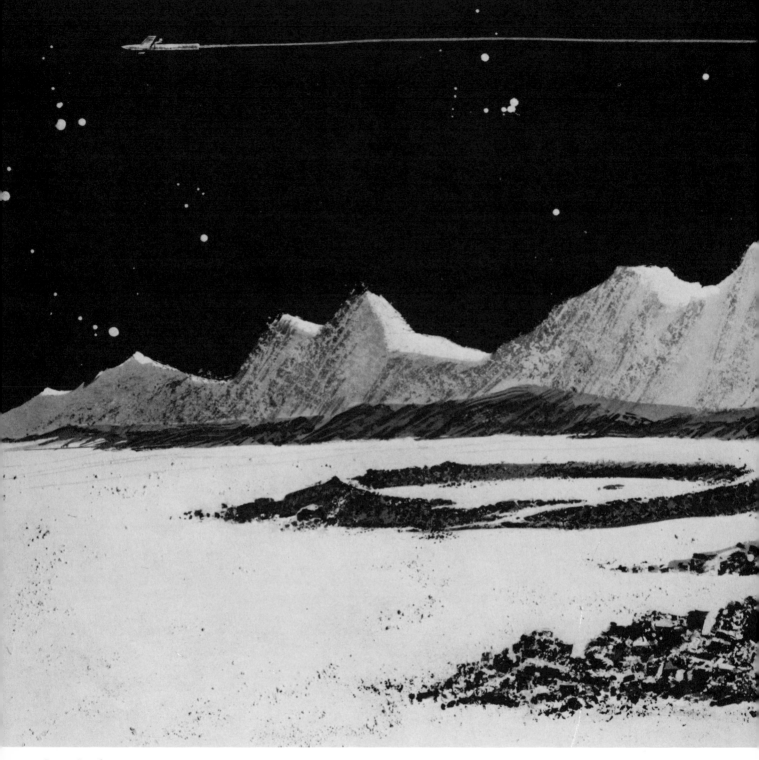

Lunar Landscape
In the airless environment of the moon, the brilliant sun burns the dusty, gritty landscape to produce strong contrasts between the foreground light and shadow. In this illustration for the book *Moon Trip*, Jerry Robinson creates texture with light in two ways: he renders the land with small, precise touches that suggest a granular texture, and he also sprinkles sand and grit into the paint. The granular texture of the paint *literally* casts tiny flecks of shadow that convey the tactile qualities of the subject.

Hillside

The varied textures here include: thick groves of evergreens, rocks cushioned in cool grass, scrubby undergrowth, moss, dead leaves, and forest litter. In the valley below, the melted snow forms crystal rivulets and streams. The entire landscape is drawn with crystalline clarity and fine detail in the sharp focus typical of textural light. This sharp, clear light dramatizes every surface irregularity, throwing details into bold relief by drawing attention to the most minute shadows and points of light.

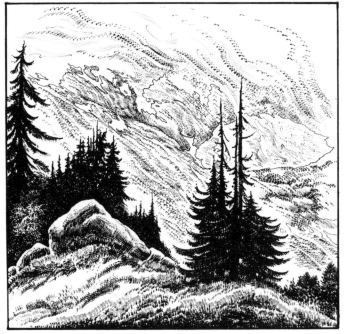

Tropical Landscape

To reveal the profusion of textures in the humid tropics, a different direction of light has been chosen arbitrarily for each object. For instance, the light strikes the tall, furry rock from the left, but comes from the right to reveal the texture of the fallen trees in the foreground. As long as the total effect looks convincing, you are free to choose the most effective light direction for each object.

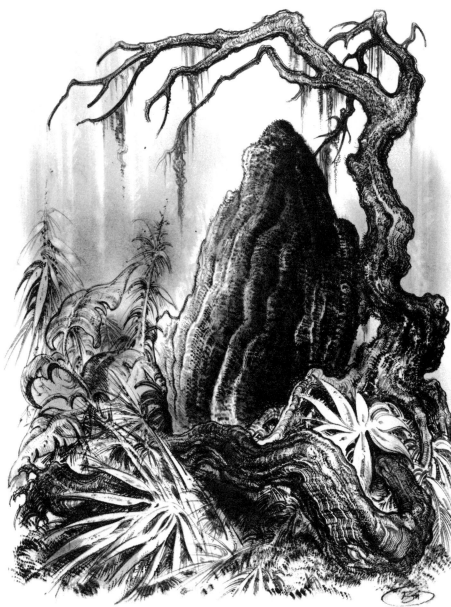

113

Landscape with Figure and Animals

This page from the author's *Jungle Tales of Tarzan* surveys not only the intricate textures of the tropical growth, but also the smooth skin of the figure, his furry loin cover, the short-haired fur of the monkey, the feathers of the owl and the singing bird, and the slick curves of the lizard and the eggs. The rough, furry, and feathery textures are rendered with lines that seek out and follow the surface irregularities, so that the touches of the pen become linear shadows. However, on the smooth surfaces, the lines simply follow the direction of the form, curving around the muscles of Tarzan and the convex surfaces of the lizard and eggs. The right line must be found for each subject. Thus, simple lines follow the movement of the water in the foreground to convey the impression of a wet surface.

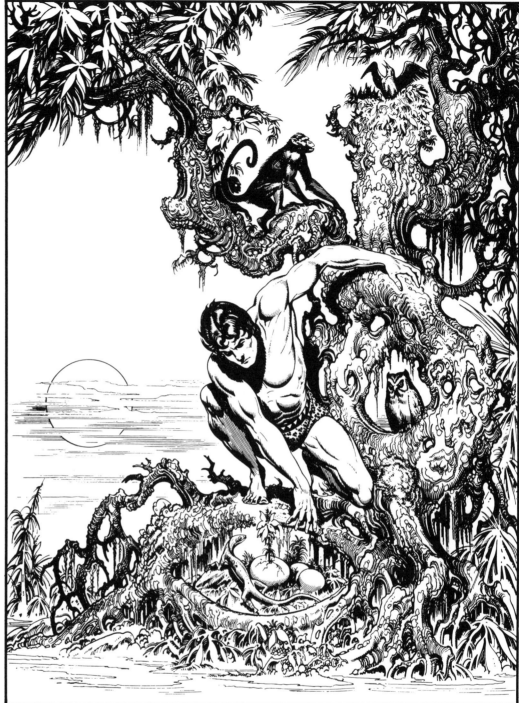

Shiny Object

A shiny, metallic object presents a smooth, highly polished, mirrorlike surface with high reflectance. Such a surface produces bright highlights. In this hose and pipe connection device, the connector is bright metal, while the hose is smooth, dark plastic. Thus, the hose is mostly dark, with limited highlights and edge-light reflections while the metallic connector, on the other hand, shows more light because it has more bright, open areas. The shiny metal has a *dual* highlight system: you can see two rows of light reflections on the upper and lower surfaces, with fine, illuminated curves and rings. The brightness of the metallic highlight is a direct reflection of the brightness of the light source. (Unlike the metal and plastic, the fingers are easily identified as soft, dull, unpolished, and satiny textures. Their mottled tones produce the effect of being *in* the light, but not *reflecting* the light.)

Ripples in Water

When a stone is dropped in water, the pattern of light on high points and troughs can be seen clearly in the concentric ripples on the water's surface. The undulating, up-and-down surface shows the sequence of highlights, dark shadows, and secondary reflected lights within the troughs. As you have already learned, the bright light on the form appears next to the deepest dark. Notice how the sequence of tones moves diagonally, from lower right to upper left, across the major axis of the wave pattern. You will find that similar highlight effects appear on other wet surfaces, from the human eye to the wet *look* of shiny paint, glass, or chrome.

Shiny Cloth

Polished metal is not the only material capable of producing reflected highlights. A similar effect appears on this young sailor's rubberized slicker, with its hard-edged folds, angular corners, deep depressions, and sharp crests—like squeezed tinfoil or finished leather. There are bright highlights on the topmost forms of the wrinkles, particularly on the sleeve, and deep shadows in the troughs. A special characteristic of such shiny material is the presence of secondary, reflected lights within the deep clefts of the wrinkles. Once again, the distinctive quality of textural light is in its precise definition of the crisp lights and shadows on an object—as well as in the sharply drawn reflected lights in this example.

Reflections in Glass and Metal

On the polished glass and painted metal of this car on a bridge, the light is mirrored to create the tactile sensation of smoothness. The characteristic ripple appearance on the windshield and hood is not the result of surface irregularity, but the mirrored image of the trees and sky. The chrome on the lights, grille, and bumper also produces brilliant light and dark reflections like the water in the previous illustration. Around the car, the textural light reveals the intricate pattern of tiny lights and shadows that conveys the surface qualities of abrasive bark, weathered wooden beams and planks, chipped fieldstone, and clumps of leaves.

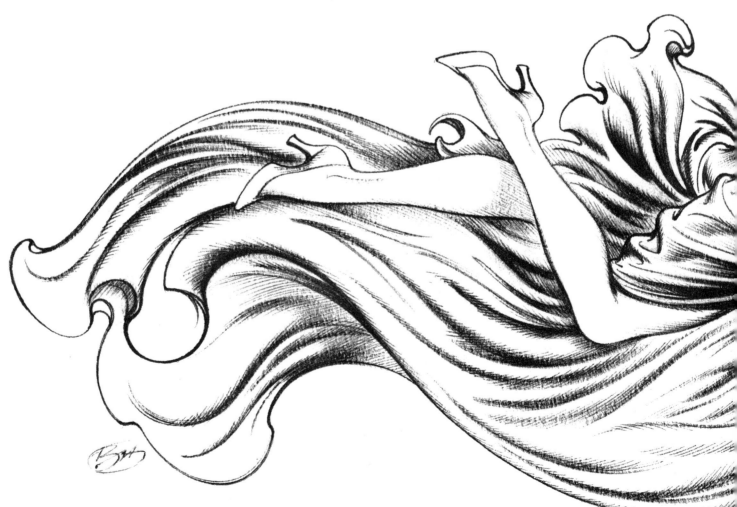

Varied Landscape Textures
The water, rocks, and trees in this landscape set up a sequence of tactile experiences, all communicated by the textural light—the dense, terraced stone; the splashing, cascading stream; and the intricate foliage. All are revealed and *heightened* by the strong contrasts of light and shadow that are typical of textural light. Thus, the tops of the rocks are brilliantly lit from a high source, which creates tiny pits of shadow that convey texture. The shadows themselves are strong and dark, but are rich in textural detail because they contain a great deal of secondary, reflected light. In the same way, clearly defined lights, shadows, and reflected lights bring the textural details of the trees and foliage into sharp relief.

Silk and Satin
At first glance, a silky or satiny material has a surface that seems similar to the high gloss of metal or glass. However, there is a difference. A polished surface is slick and undisturbed; thus, it is highly reflective. But the woven surface of satin or silk, no matter how fine the mesh, has an airy or dusty look, and is less reflective. Therefore, this woman's dress inherently lacks the brilliant shine of the smoother, "wet-looking" surfaces in the previous four illustrations. Instead, flowing in the direction of the curves and thrusts of the body, the wrinkles of the dress express the tactile qualities of softness and flexibility. To render the textural light on these voluptuous surfaces, the shadows are modeled with lines that follow the contours of the sensual folds and wrinkles of the dress.

TRANSPARENT LIGHT

Transparent and Translucent Light

Transparent surfaces and objects actually transmit light. These light-penetrating or light-permeating qualities are inherent in the structure of such solid matter as glass, crystal, gems, and ice; in captured liquids like water or wine; and even in captured gases, such as bubbles. Translucent substances permit light penetration, but tend to absorb light, interfere with the light, or diffuse the light, thus introducing a degree of opacity that reduces the clarity of the image. This translucent effect is familiar in gauzy fabrics, liquids, the flat surface of ice, and frosted glass.

Clear Glass

The clear, transparent glass of laboratory vessels, seen against a window in broad daylight, presents an effect of outlines with no suggestion of solid form or solid matter. Each light-permeable object seems to be made of contours only— looking like a wire construction. Below the window sill, glass jars are set against the shadowy frame. Here, their contours catch occasional light: bright outlines contrast with the dark outlines of the forms above.

Refracted Light

A clear glass bowl—with varied diameters—displays a sequence of see-through elliptical shapes. The light is refracted by the thickness of the glass. Arc-shaped reflections follow the *convex* shapes of the bowl, while the eye-shaped reflections appear within the *concave* curves. The effect of the transparent light is particularly complex and fascinating because you are seeing the inner and outer surface at the same time, since the inner and outer reflections shine through one another.

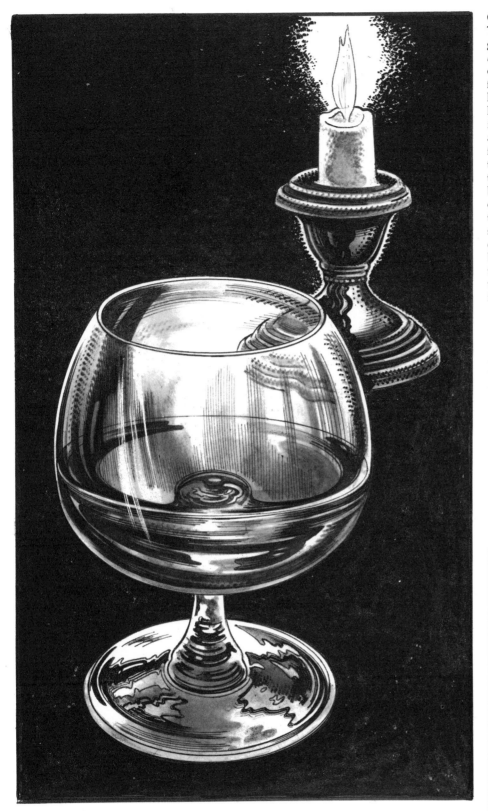

Glass, Fluid, and Metal

The rounded, frontal surface of the snifter glass is defined by a series of curved, *up-and-down strokes*, with intermittent slashes of highlights. Curving *horizontal strokes* define the concave inner surface beneath the lip at the rear. Curving, *circular strokes* delineate the liquor in the glass; note that the fluid is seen both from the side and from above. Within the fluid, arcs of light define the stem attachment, showing through the liquor. Beneath the glass, these arcs are repeated on the stem and base of the glass. The irregular reflections on the base suggest the imprecise finish of the glass. Through the back wall of the snifter, a fairly sharp image of the silver candle base is seen. But where the candle base is seen through two layers of glass—the front and back walls of the snifter, one wall concave and the other convex—the image is distorted and less bright.

One Glass Behind Another

The two wine glasses contain a colored, translucent fluid. Sharp highlights follow the outer curves of the glasses. On the surfaces of the liquid, elliptical lights vibrate gently. Where the glasses almost touch, we see the dual image of the left glass behind the right. The stems gleam with light from a small pattern—brightest on the higher surfaces. The disk-shaped bases show curved reflections. The lights on the surfaces of the glass are distinctly brighter than the soft, inner light of the wine within.

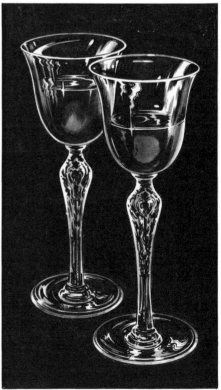

Ice and Bubbles

The translucent tumbler contains layered, melting ice that floats in carbonated water. Bubbles seep upward, leaving trickling paths as they move toward the surface of the water, from which the random shape of the chipped ice projects. Above the rim of the glass, minute bubbles pop as they escape into the air. The tumbler is clear against the dark background. Only the horizontal strokes on the lower surface of the glass suggest reflected light and affirm the solid structure of the vessel. Note the wet, wavy reflection on the surface beneath the glass.

Ice Cubes

The irregular facets of ice cubes present an intriguing problem because there is no explicit image that you can see through the ice and no reflection of a specific image on the surface. Yet there *is* light penetration and refraction, and there *are* highlights and reflections from sources that may not be apparent—like the dark facets that come through from the dark background. The only way to draw these phenomena is to observe the seemingly random patterns and record them faithfully. If you do so, a convincing effect of transparent light, and a solid sense of form, will emerge by themselves.

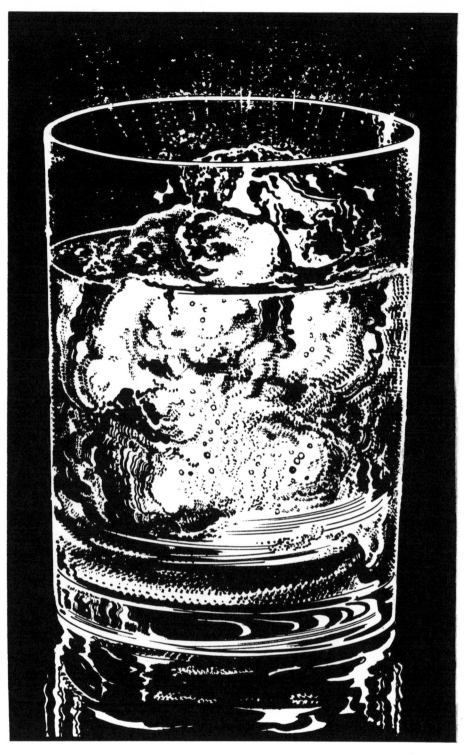

Crystal Form

This symmetrical polyhedron presents brilliant light on some facets, diminished light on others, varied reflections, and reduced transparency where one facet interrupts or overlaps another. The surface light changes with every directional turn of the geometric form, yet each facet is polished and precise as a prism.

Cut Glass

The sparkling highlights on the raised, prismatic pattern of cut glass tend to disguise the transparency of the dark liquid within the glass. But the see-through color of the fluid glows through the upper part of the wine glass. The light shines *through* the stem, revealing the form by the effects of light on the intricate pattern. In contrast, the light shines *on* the base, and its form is revealed by the circular reflections on the surface.

Gem

The prismatic, crystalline quality of the light that emanates from a gem is a kind of transparent light that is *not* seen in glass or any comparable material. The light that strikes the stone is turned *into* the stone instead of passing through, and then reflects outward in a display of spectral colors of great brilliance that gives these minerals their strange and wonderful "fire." Once again, the secret of drawing this type of transparent light is to observe the abstract pattern and record it faithfully, no matter how erratic that pattern may seem. The light has its own secret logic, inherent in the structure of the crystal.

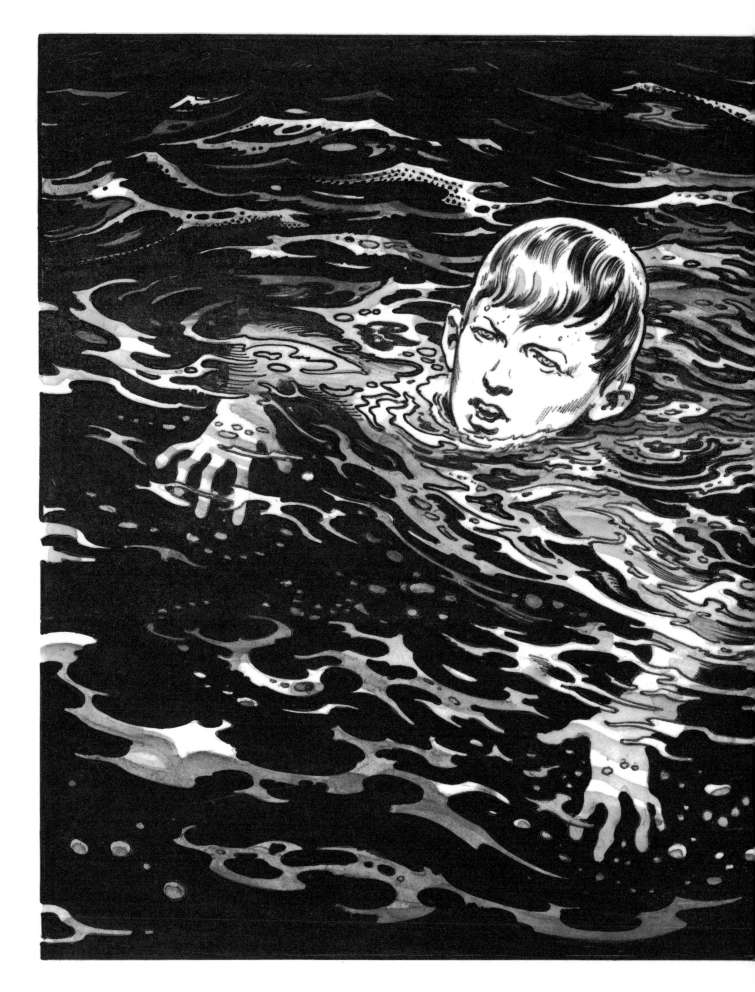

Moving Water

The transparency of water is affected by a variety of factors. Thus, we can see the forms of the figure that are just below the surface, while the rest of the figure is quickly obscured by the density of the water and the increasing darkness below. The form is also obscured and distorted by the motion of the water and the refraction of the light. Finally, the water is really *translucent* rather than transparent, letting only *some* light through and partly obscuring the image beneath the surface. Such ambiguity and obscurity are frequent occurrences in translucent light.

Two Kinds of Translucency

There are two different kinds of translucent effects in this drawing of a car. Although the windshield glass is absolutely transparent, the interior detail of the car is somewhat obscure and pale because of the light that enters the car from the side. The effect is similar to the translucency of air laden with fog, mist, or dust. The other translucent effect in this drawing is seen in the frosted glass of the headlights: the striated surface pattern diffuses the light penetration of such a surface and blurs any image seen through the glass.

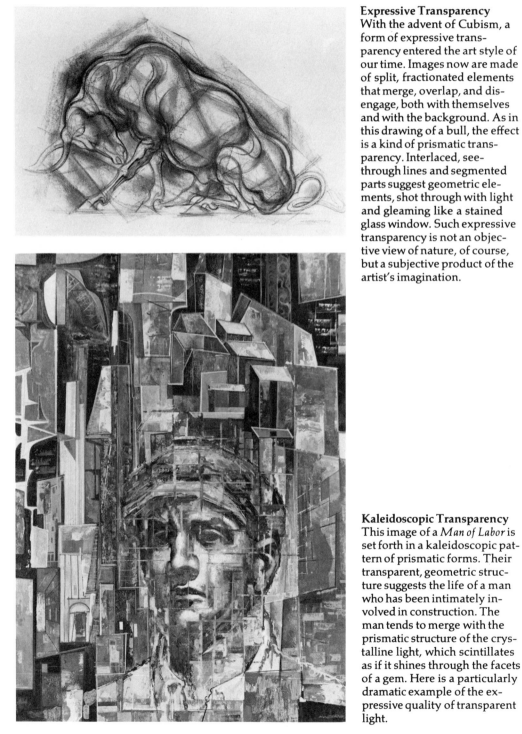

Expressive Transparency

With the advent of Cubism, a form of expressive transparency entered the art style of our time. Images now are made of split, fractionated elements that merge, overlap, and disengage, both with themselves and with the background. As in this drawing of a bull, the effect is a kind of prismatic transparency. Interlaced, see-through lines and segmented parts suggest geometric elements, shot through with light and gleaming like a stained glass window. Such expressive transparency is not an objective view of nature, of course, but a subjective product of the artist's imagination.

Kaleidoscopic Transparency

This image of a *Man of Labor* is set forth in a kaleidoscopic pattern of prismatic forms. Their transparent, geometric structure suggests the life of a man who has been intimately involved in construction. The man tends to merge with the prismatic structure of the crystalline light, which scintillates as if it shines through the facets of a gem. Here is a particularly dramatic example of the expressive quality of transparent light.

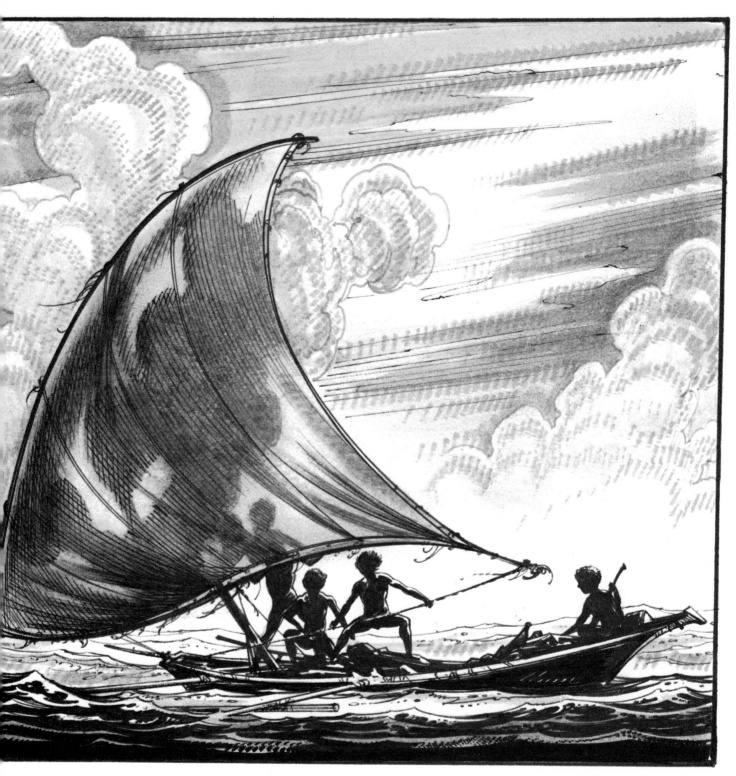

Translucent Cloth
Certain kinds of cloth—such as loosely woven cotton, lightweight knit, or fine silk—allow the light to penetrate and thus reveal an unclear image, usually a silhouette. Here, the canvas sail catches low, late afternoon light. Clouds rise in the warm updraft. The boys are illuminated by the hot afternoon sun. The sun is still bright enough to shine through the sail, which transmits the silhouettes of the clouds and the figure of one boy.

FRAGMENTATION LIGHT

Light Disrupting Form
Fragmentation light is an instantaneous or momentary effect of reflected light that suggests disrupted or dispersed form. This is not the changeable light of the Impressionist painters, but a transient light phenomenon of disintegrated form—such as splashing water, flying snow, or an explosion. Such light suggests *motion* happening in a very brief time. Fragmentation light is immediate, passing, and often tumultuous.

Rain
Water run-off in rain produces a distorted reflection of an auto wheel on a wet street at night. The streaming water creates an uneven mirrored surface that imparts a trembling shimmer to the reflected form of the wheel. All the well-ordered elements of the car take on a fractured, corrugated quality as they are reflected on the half-lit, oil-slicked, gleaming street, while the streaks of rain create a sporadic, angular pattern of light over all the forms.

Twilight on the Sea
In the murky twilight of an overcast tropical sky—the moment before a storm erupts—the heaving swells catch the last glimmer of the light. A pattern of alternating crests and troughs gleams brightly, but we see the pattern of the light rather than the actual shapes of the waves. The sea gleams with whorls and eddies in the foreground, changing swiftly as we watch.

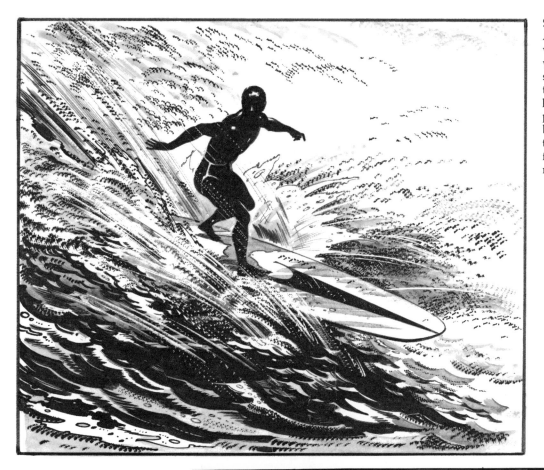

Surf
As a surfer plunges shore-ward—impelled by a booming wave—the foam, spume, and spray explode outward in glistening beams and motes of light. The volatile, kinetic display of the surf releases boundless energy, dispersing the light and fracturing the forms seen through the fragmented light.

Explosion in Water
High explosive charges, dropped on a submarine, send radiating geysers and plumes of water in all directions. At the core of the blast is a massive eruption of aerated spume and spray that reflect the brilliant, fragmented light. The rocking of the ship produces a sequence of lateral waves, while the rubble cast out from the vessel creates splash patterns in choppy rosette forms. Against the dark water, the light gleams on these fragmented shapes.

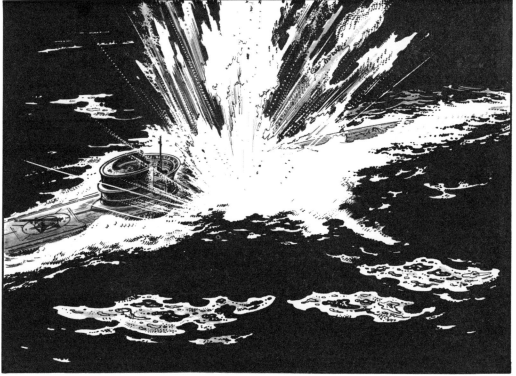

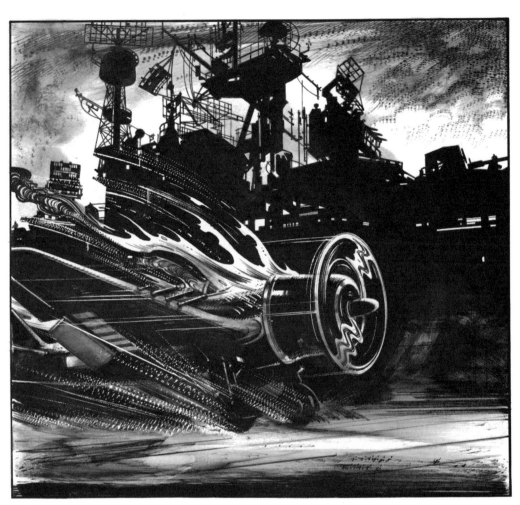

Fire
Aboard an aircraft carrier during a battle, a plane returns disabled and on fire. The fragmented light appears not only in the flames and smoke that flare to the rear, but also in the streaks that fly from the skidding wheels, and in the sheen of the polished propeller blades.

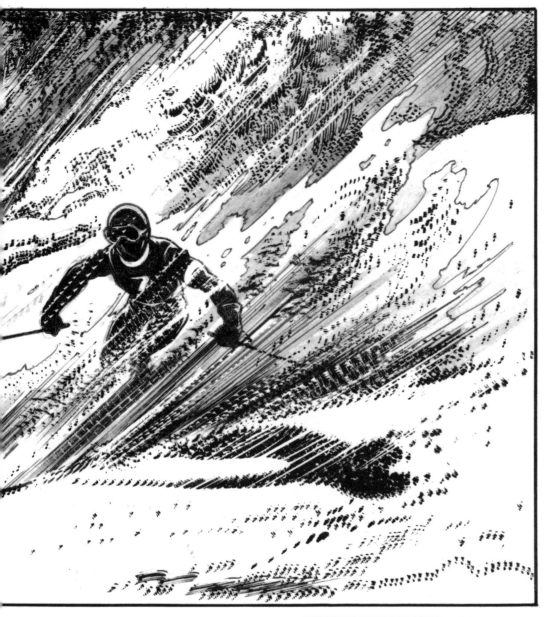

Powdered Snow
The downhill racer moves at a "breakneck" pace through a shower of snow powder and ice. The light disturbance is caused by the shower of snow that explodes skyward, augmented by a heavy updraft of wind from below. The look of speed—which is frequently identified with fragmentation light—is emphasized by the angular strokes of the grainy background, without any identifiable detail.

Sand
A sand buggy plunges downward in a shower of sand, grit, and pebbles. While the front wheels throw up waves of dirt, the back wheels kick up a storm of debris and dust in all directions. The dust-filled air creates a fragmentation pattern that obscures everything around the racing automobile.

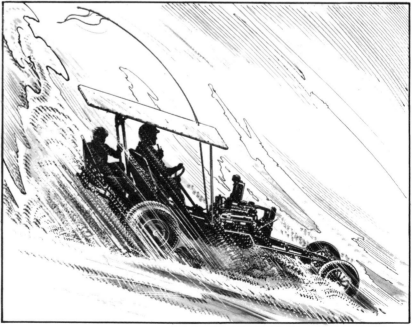

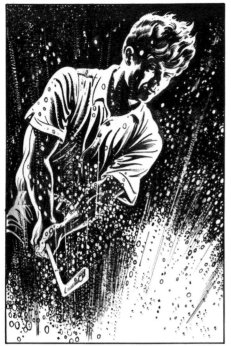

Golfer in Action
As the golfer delivers the ball out of a sand trap, the impact of the stroke creates an upheaval of fine and coarse sand—like a miniature explosion in a radiating flare pattern. The fragmentation light dissolves all adjacent forms and details.

Racing Car
This racing automobile creates a variety of light disturbance patterns. First, of course, there is the airflow and slip-stream speed pattern created by the tremendous velocity of the machine. Next, the effluent gas spirals far behind the auto as the exhaust is caught in the air turbulence produced by the vehicle. Third, a chattering pattern of light appears close to the ground as the wheels hit the cobbled road with thunderous force. Finally, the uneven density of the moving air is expressed in spasms of cloudy light-and-dark passages that spread sideward from the speeding car.

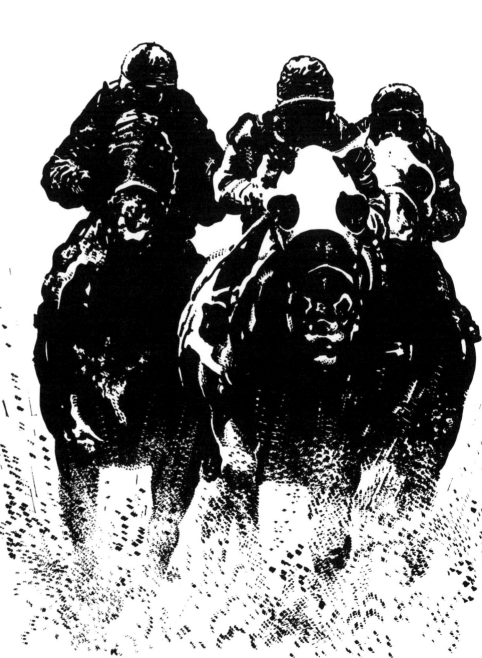

Horses in Motion
Racehorses, converging shoulder-to-shoulder toward a dead-heat finish, send up an eruption of track debris that obscures even the galloping hooves. The light is dispersed by the flying granular matter, which cancels out all specific details of the moving legs of the animals.

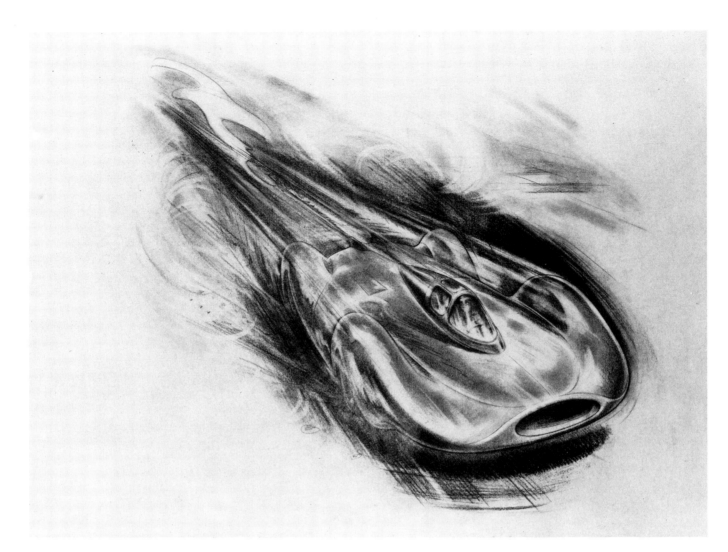

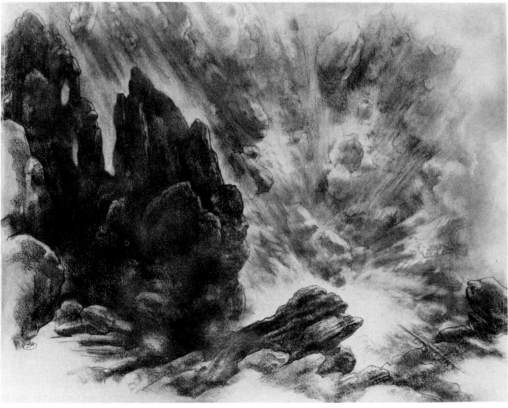

Avalanche
Fragmentation light of another order appears in an earth convulsion when rocks, snow, and ice cascade down a mountainside. Great masses of rock and ice, in riotous collision, explode like bombs and send bursts of rocky rubble and crystalline ice and snow toward the sky. Earth, snow, and debris spread everywhere, rifted with mist, fog, and curls of drifting glitter, all dissolved into pale, cloudy vapor.

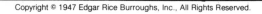

Volcanic Eruption
The most spectacular manifestation of form-disintegrating light is the boundless violence of a volcanic eruption. Great, belching coils of smoke and dust spew out in a monstrous flare pattern, cut through with geysers of flame, molten debris, and shattered rock, all flung skyward. An unearthly light bursts through the sky and flaming embers plummet all around the four survivors in their fragile craft.

Light in Motion

A lesser mode of fragmentation light—what might be called *kinetic light*—is shown in this drawing of violent movement, shock, and disturbance. The lines of kinetic light suggest speed and thrust as the knife is driven with great force into the reptile's skull. The frozen image printed on the page does, indeed, *seem* to move; the arm swings and the snake recoils.

Light Conveys Intense Feeling

Kinetic light—or action light—expresses speed and urgency in this drawing of a clash between a jungle man and armed pursuers. A powerful blow—drawn as an explosive burst of light—sends one enemy flying heels-over-head. Curved speed lines convey the action of the blow, while similar lines of kinetic light intensify the frenzy of the hurtling figure. The expressive use of action light conveys a quality of feeling so intense and immediate that one is surprised that artists except for cartoonists, have used it so sparingly.

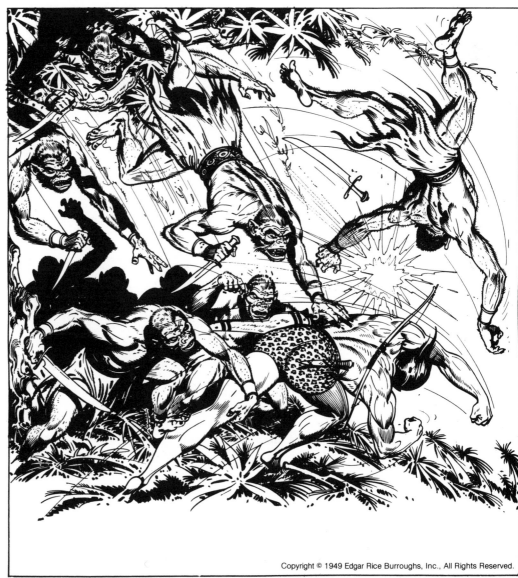

CHAPTER 14
RADIANT LIGHT

Intense Light

Radiant light is an intensive emanation of light—natural or artificial—far more powerful than direct, single-source light. Such light is an assault on the eye because unlike translucent light, radiant light is never screened, nor is it reflected from a secondary surface. In single-source light, we see the bounce effect of a strong light on an object. But in radiant light, the eye is in direct contact with the light source itself. The viewer is powerfully aware of temperature and energy. By definition, the primary and pervasive example of radiant light is our universal energy source, the sun. In degree of intensity, radiant light ranges from the comparatively low illumination of a candle, to the intermediate range of a lamp or flashlight (or even a searchlight), to the high levels of radiance produced by a fire or an explosion.

Glare

Radiant sunlight produces the perceptual phenomenon of glare—the spill-over of light rays, striking the eye with so much intensity that the viewer is dazzled and discomfited, finding it difficult to perceive the shape of the light source because of its overwhelming luminosity. (We have all experienced the reflex of narrowing our eyelids so that the eye becomes a thin slit.) Glare is produced not only by the sun, but by any "hot" light source that strikes the eye directly, such as an auto headlight, a propane flame, an arc light, or vivid firelight. These effects are best seen against dark backgrounds.

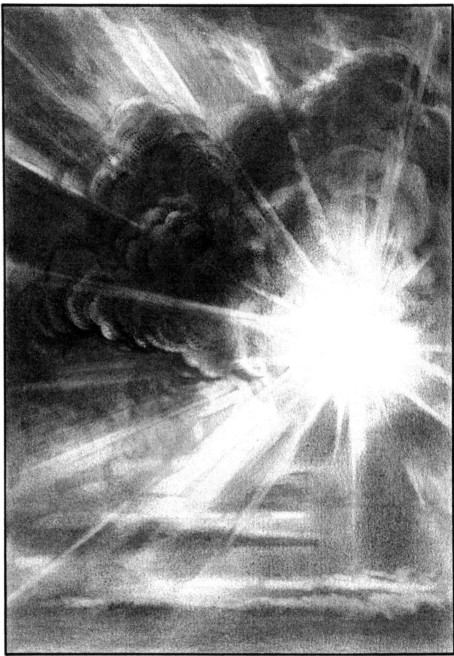

Sun

Breaking through a bank of clouds, the sun emits a sudden, unobstructed blaze of dazzling brilliance. The contour of the solar disk cannot be seen because of the glare—the spill-over of radiant light. But, here and there, flashing rays shoot through the clouds, sending beams across the afternoon sky.

Candlelight

In contrast with the pervasive, immense power of the sun, we now see the lambent shine of a candle flame. Note the soft, warm illumination of this low-level light—equivalent to match light. Its dim luster bathes the woman's face with a subdued glow and suffuses the background with a pale half light that fades gradually into shade.

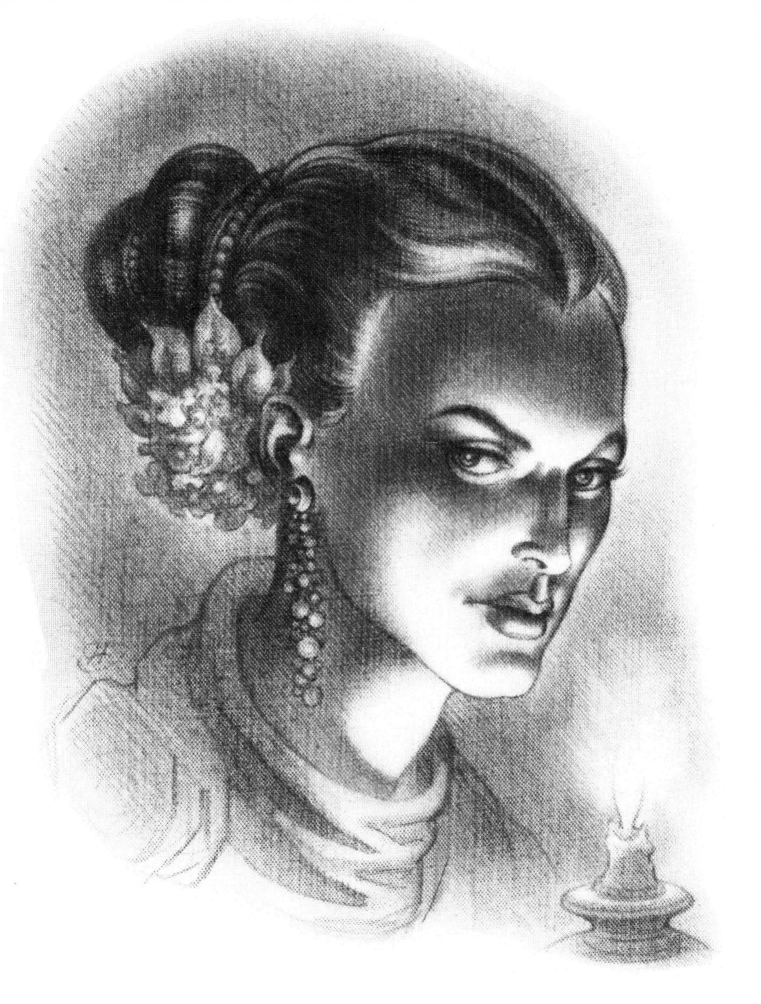

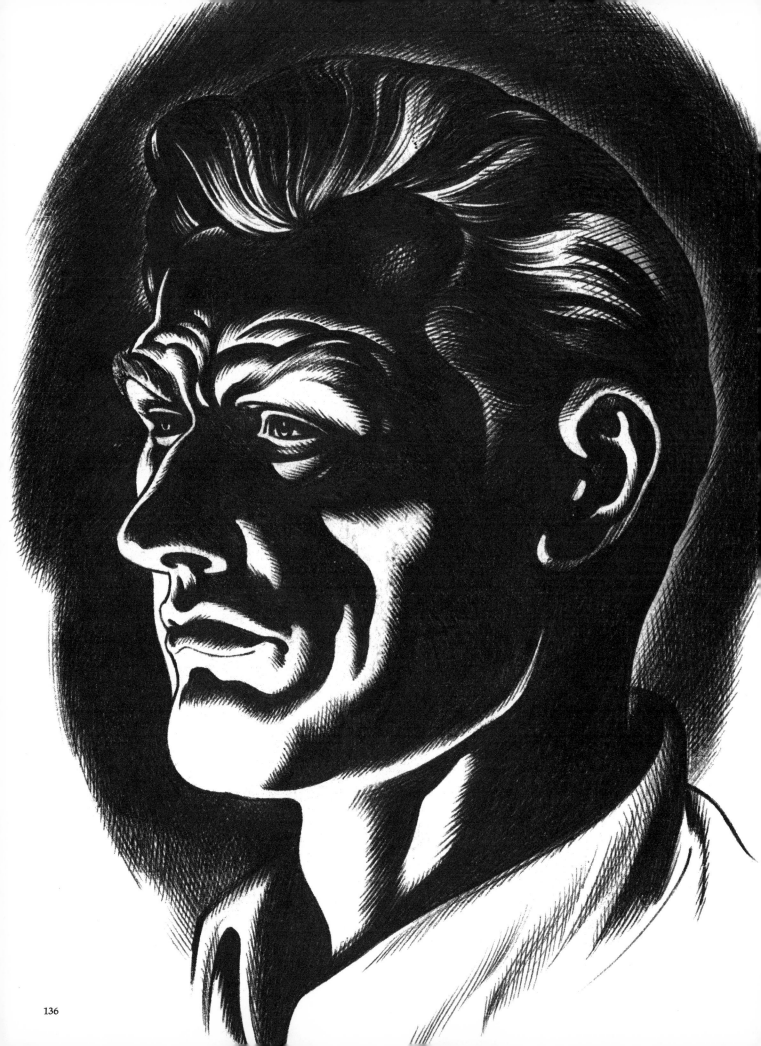

Firelight
This male head is illuminated by flamelight from logs in a fireplace or, possibly, an open-air campfire. Compared with the soft candlelight in the previous drawing, the planes of this head are sharply defined by the hot blaze. Subtle half-lights have no place here. Bright lights are placed against equivalent, pitch dark shadows that merge with the tenebrous background.

Flamelight
The flame of a cut glass, tallow oil lamp sends scintillant light through the prismatic surface of the glass. The concentrated light is brighter than a candle flame. Thus, the lamp emits sparkling rays, producing marked contrasts of light and shadow on the figure.

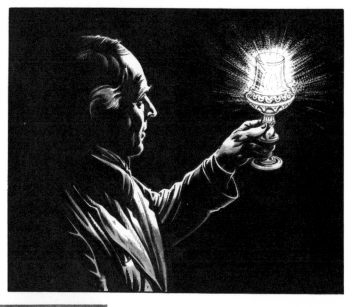

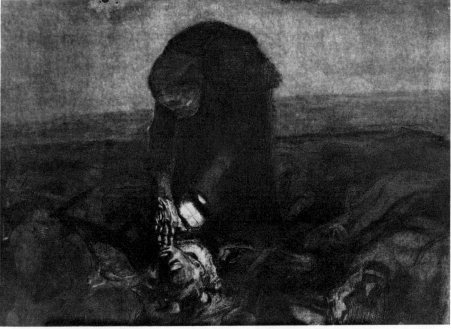

Lamplight Outdoors
In Kaethe Kollwitz's great etching, *Schlachtfeld*, a woman carries a low-power lamp as she searches for a loved one on a battlefield. An eerie, feeble, yet intimate light glows on the features of a fallen soldier. The cool light—probably from a carbide flame—is just above a glimmer, and flickers in the damp wind as the fragile gleam threatens to die away in the night.

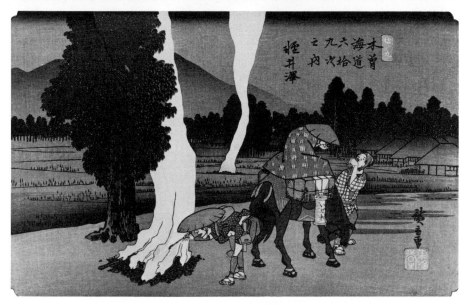

Flamelight Outdoors
In this color woodcut, the Japanese master Hiroshige gives us flamelight that issues from peat fires, whose bright columns of flame rise almost vertically in the still, cool air of the darkened landscape. The light is not as untamed or dramatic as that of the torch in the previous drawing. Here, the radiant embers and the hot gases rising into the sky have an inviting warmth. Note the small paper lantern that is suspended from the horse's right side; the simple candlelight contrasts with the large peat fires.

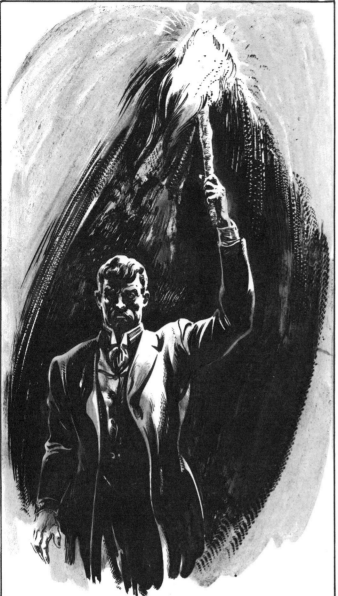

Flashlight
The strong, concentrated beam of a flashlight cuts a swath through the darkened interior. If we look directly into its glaring beam, we will instinctively shield our eyes. This battery-powered light is essentially cooler than the thermal energy of a peat or log fire. But the flashlight is *more intense*. This is an important distinction: the peat or log fire is hotter, but not brighter.

Torchlight in Wind
An oil-soaked taper or torch flares unpredictably in the wind, acting like a flaming mare's tail. The light is not even or constant, but is fitful or blazing bright. The torn flame creates uneven lights and shadows that leap and play, looking both benign and menacing at the same time.

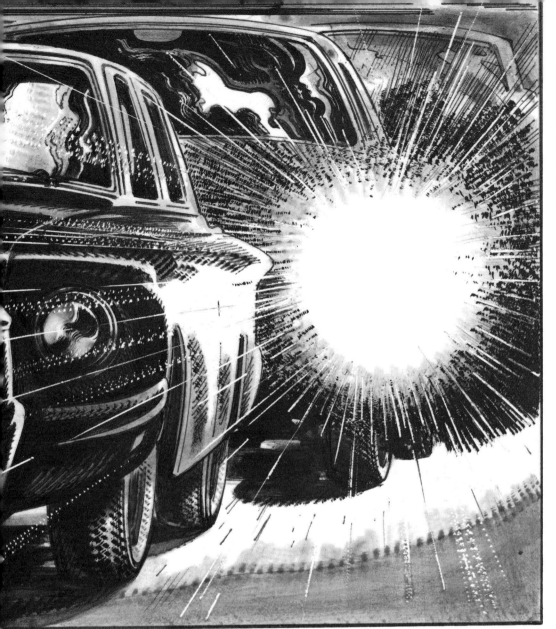

Auto Headlight

Like the flashlight, the automobile light is artificial and therefore "cool." But it is "hot" to the eyes. As we look straight into the bright beam, we see an spill-over of light that spreads fanwise in all directions. We cannot see the contour of the circular headlamp from which the rays originate. We see only a burst of high-intensity glare.

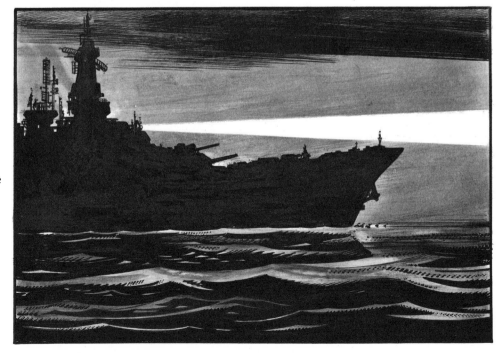

Searchlight

On a far larger scale than the automobile headlight, the battleship's searchlight stabs through the moonless overcast with a beam that can illuminate an area hundreds of yards away. Seen here in a side view, the far-reaching shaft of light pierces the darkness with a knifelike, luminous thrust that can penetrate gloom, mist, and darkness to an enormous depth. Viewing such a powerful light head-on—with the naked eye—one would suffer unbearable pain and extreme optical damage.

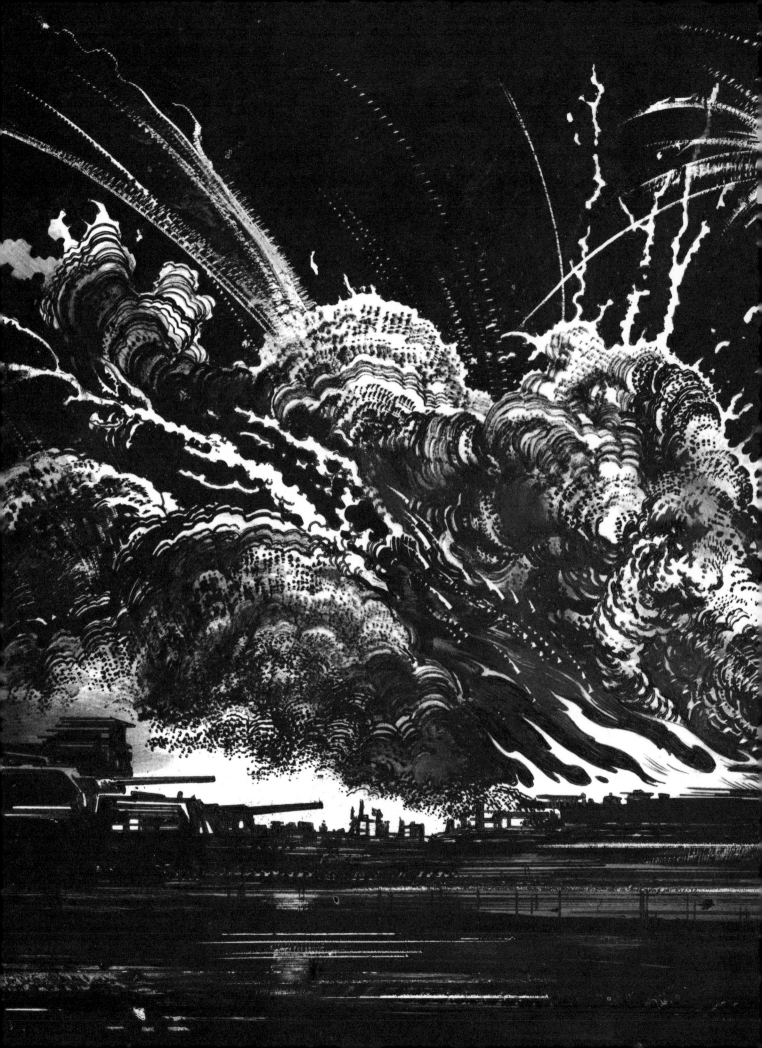

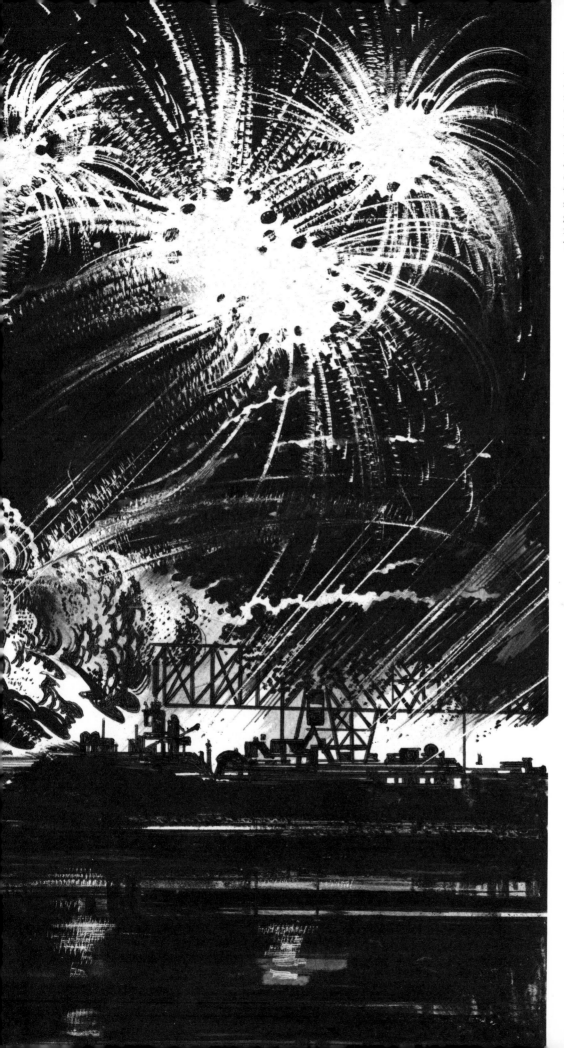

Explosion
A conflagration in an exploding ammunition dump looses a series of fires and radiant light effects. Great tongues of flame lick the sky as convoluted volumes of smoke billow upward. Innumerable small fires spread across the ground while the dark sky is rent with a pyrotechnical display of bursting shells, flares, and tracers. It is a garish scene of multicolored radiance, fearful and awesome, yet perversely fascinating.

Fiery Lava
Looking closely at the aftermath of the volcanic explosion, we see the radiant light of the glowing, molten rock, flowing down the sides of the mountain, shooting out sparks and flames, and exuding gaseous smoke. It is an awesome scene, like the open bowels of hell itself.

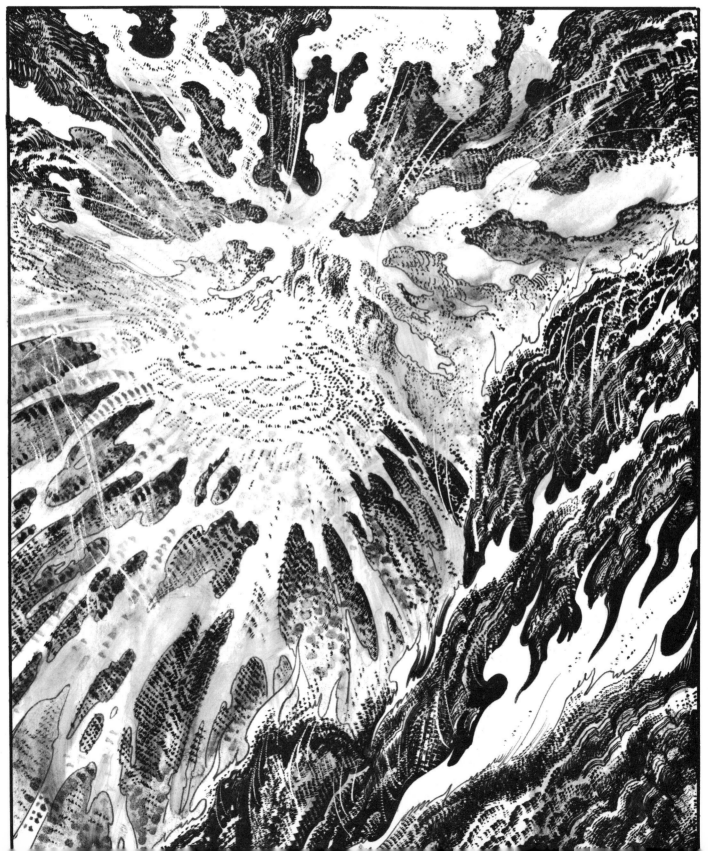

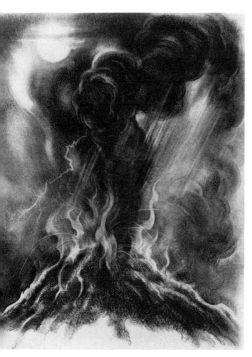

Volcanic Eruption
Here is another display of light
and energy on a grand scale. As
molten lava pours onto the
flanks of the mountain in fiery
rivers, columns of dust, smoke,
gaseous flames, and sulfurous
debris obscure the sun. The
light is as dim as moonlight,
and flashes of lightning strike
across the gloom. There are
many aspects of radiant light in
this drawing, from the pale
glow of the sun to the fiery ex-
plosion below. Each effect de-
serves close examination.

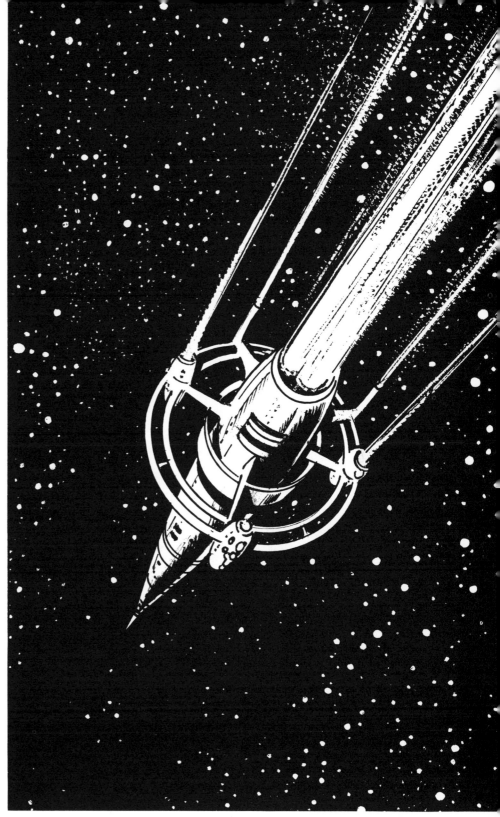

Radiant Light in Space
The jet nozzles of a space
rocket emit hot gases in an in-
candescent stream of radiant
light, similar to the bright tail
of a comet. As the jet craft
moves at enormous speed,
without gravity or friction, we
see multitudes of distant,
gleaming stars, like radiant
pinpoints everywhere in the
velvety, infinite dark.

EXPRESSIVE LIGHT

Subjective Light
Until now, we have dealt mainly with actual light conditions—objective light that we can see in nature. Now we turn to nonvisual, subjective light—various kinds of light that are invented by the artist to deal with internal, subjective, emotive qualities of mood and introspection. Among these are mystic light that emanates from the human form like a halation to suggest spiritual energy or divine power; light that reveals an emotion or a state of mind, such as emotional stress, alienation, loneliness, or pain; suggestive light, in which a minimal use of tone conveys an emotional message; and light as design, which means organizing the lights and darks to create a pictorial structure that will direct the eye along a specific track.

Spiritual Light and Earthly Light
Albrecht Dürer's woodcut of the *Madonna on the Crescent* shows two kinds of light: spiritual and earthly. The spiritual light of the Virgin and Child radiates glory into the universe, while the sickle moon sends golden rays outward into the cosmos, and the bright stars gather and dance in a halo of divine light above the Virgin's head. In contrast to this subjective, nonvisual light, the forms of the figures are shown in earthly, sculptural light that is not governed by the transcendent heavenly glow.

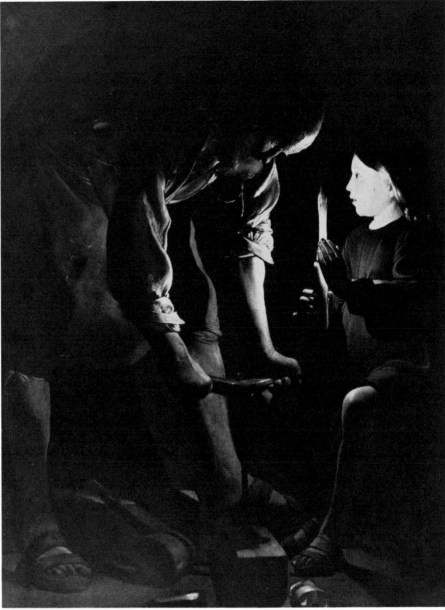

Symbolic Light
Georges de La Tour's *Saint Joseph the Carpenter* seems, at first glance, to exhibit the radiant light described in the previous chapter. Naturalistic light appears to come from an objective source: the burning candle held by a young boy who helps his father with his work. But the man is Joseph the Carpenter, husband of the Virgin Mary, and the boy is none other than the youthful Jesus. Thus, the carefully shielded candle flame is a symbol of the light of God, which falls full on Jesus' face, lights up Joseph at his "goodly works," and is the metaphor for the light that now illuminates the dark void of the world.

Mystic Light

In the Christian tradition, a holy person is illuminated by the *chiaroscuro* that is typical of Baroque art. Deep pools of shadow underscore the lines and forms of this face that has known travail and sorrow. But a faint light is seen above his head, appearing like a crown with rays that fan outward into the world. It is important to note that this subtle halo is *not* the same naturalistic light that illuminates the face of the saint. The halo is an unearthly, mystical light that issues from within the person, expressing his state of grace.

Light as Revelation

In a tale told by Edgar Rice Burroughs, "The God of Tarzan," the Jungle Man discovers his personal God of the Universe. Here, in a moment of insight, he faces the light and hails the source of the mystery with upraised arms and hands open in benediction. At the same moment, a white bird with upraised wings—divinely inspired—is about to alight. The glow of the sky magically illuminates the tranquil scene. The man wordlessly greets the miracle as the branches unite their flowery growths to form candelabras that send shoots skyward like living, holy flames.

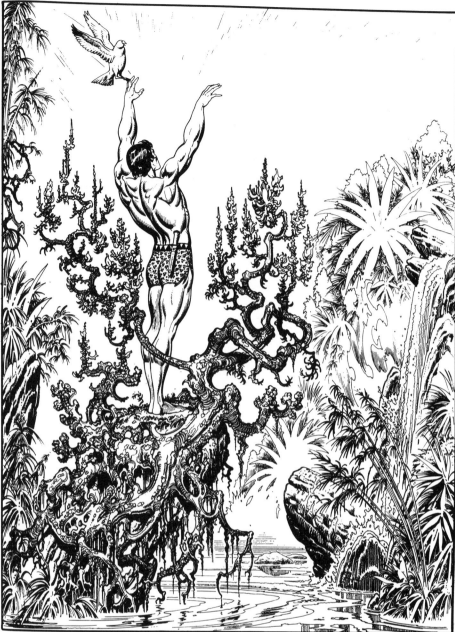

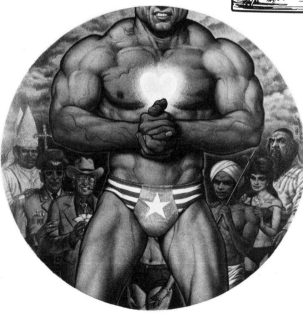

Charismatic Light

Mystic light is not always cast in a religious mode. Illustrator Don Punchatz conveys both physical and mystical power in this vision of a strong man who wears athletic briefs like a comic book Captain America, flexes his muscles, and displays a radiant heart of strength on his chest. The clenched teeth and gripped hands signalize—with the heart that glows like an incandescent lightbulb—the hero's power to prevail over the influences and temptations that surround him.

Metaphoric Light
A multitude of twinkling, ephemeral lights occur throughout this painting, *Icon of Homage to the Moon Queen*. She is the Great Mother, a fertility symbol as well as a seductive Broadway queen of the night. She is surrounded by lights that refer to the symbolism of ancient cultures—Egyptian, Greek, Buddhist, Christian—as well as contemporary society. The Egyptian Eye of Divine Perception, *Sia*, is in the upper left. The totemic bird halo—vulture, eagle, and crow—is above the head. At the right, you see the glimmering Tree of Fertility and the Lotus Flower. And throughout the painting, flashes of light suggest the glitter and gaudiness of Broadway after dark.

Phosphorescent Light
A luminous halation appears around the head and body of this figure in a painting titled *My Brother Abel*. The arbitrary, phosphorescent light—distinct from the objective light on the figure itself—suggests energy that radiates from the body, symbolizing life, vitality, and resistance to pain and suffering.

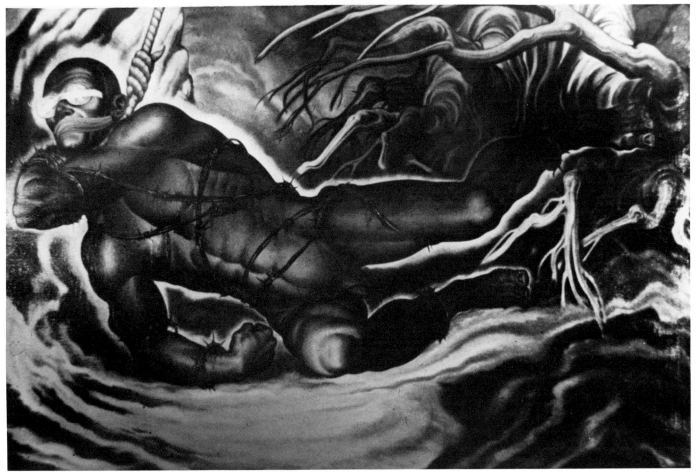

Softened Edges

In this reflective, sober drawing of *The Scholar*, the light sits high on the head, obliterating the contour. The shadows descend in characteristic Baroque chiaroscuro, the forms becoming lower in value as they fall away from the light. The most important darks are the pools of shade that obscure the eyes. The drawing avoids hard-edged forms, thus producing a warm mood of profound calm.

Evocative Light
The uncertain, diffused light is charged with mood and feeling. The vague, subjective light and shade communicates the wan, pallid woman's intimations of death, her sense of life ebbing away.

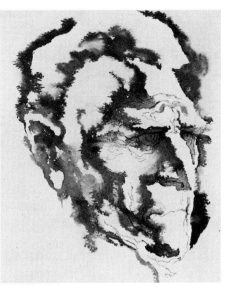

Fragmentary Light
The uncertainty and decrepitude of old age are conveyed by the fragmentary pattern of the light and shade. The shadows are gloomy and the forms washed out, spare, and dehydrated.

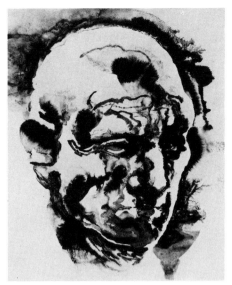

Irregular Light
The broken, irregular pattern of light and shade—with the thick, blotchy shadows—expresses the mood of a prize fighter who has seen his best days slip away into an unending series of fights. The head is like a battlefield, a physiognomic record of defeat.

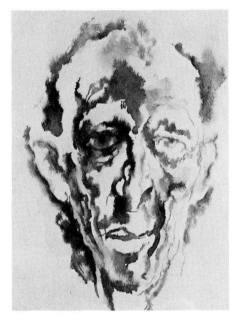

Fluid Light and Shadow
The fluid handling of ink wash and line captures the distorted pattern of the light and shade on the head of Jake the "wino." This pattern communicates the texture of a life steeped in discord, a life wrenched and warped, dissolved in the need to drink. The ragged light reveals a human discard.

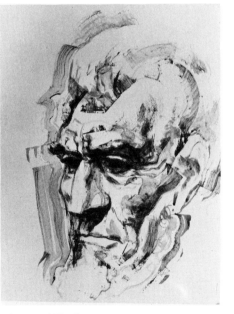

Planes of Shadow
The handling of the light and shade was inspired by Stanton's famous comment on the Great Emancipator's death: "Now he belongs to the ages." The brooding image appears to be carved from stone in firm-edged planes. To create this feeling, the shadows are laid in with a single-edged razor blade, troweling tones of tempera. The entire effect depends upon using the tool to render the pattern of light and shade as simply as possible.

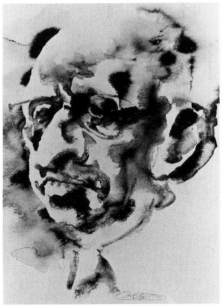

Spasmodic Light
This portrait of Stravinsky uses light and shade to suggest the character of the composer's music—often harsh, dissonant, bold, and unpredictable in its rhythms, and with sporadic changes of key. Thus, the tones are loose and fluid, with dislocated accents, frequent darks, and sudden lights.

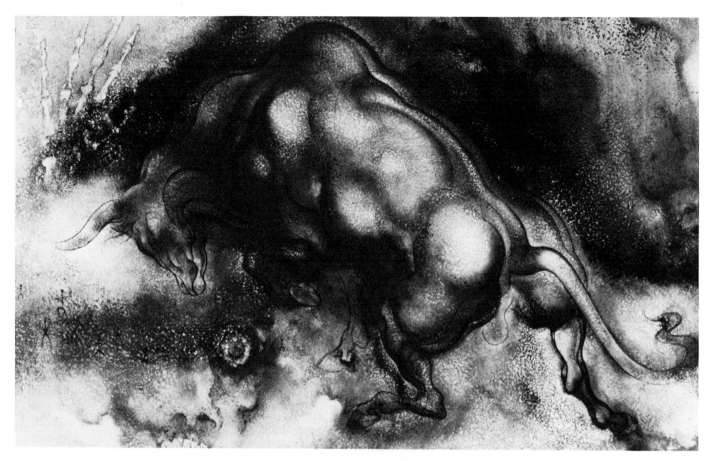

Multiple Tonalities

In this painting, *A Recollection of Lascaux*, there is no special source of light, but there are multiple light effects that act in counterpoint, like separate musical lines. The figure of the bull is the pivotal form in the painting, partially laid in with deep form shadows and partly with emphatic linear contours—to recall the feeling of line, form, and texture in a prehistoric cave painting on a stone wall. The background values are uneven and oscillating lights and darks that create a dense, yet cloudlike effect. Here and there, disembodied elements appear: the bony hand print of a dead hunter in the upper left; the wasted face of modern man, the hunter, with a radiant, atomic eye, in the lower left. Each component of the painting has its own kind of light.

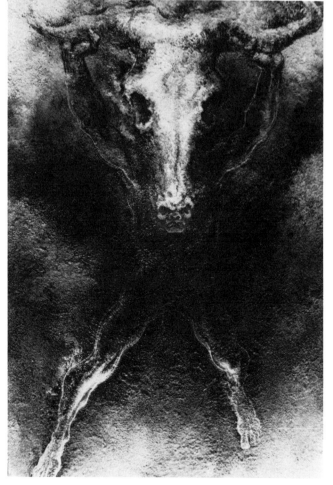

Light and Texture

The figure in *Totem Dance* hovers in the superheated, poisoned atmosphere of a nuclear explosion. The allegorical death's head speaks of the oncoming nightmare. The drama is played in two kinds of light, one from above and the other from below. (In the painting, the upper light is blue-green and the lower light is yellow-orange.) The oppressive drama of the light is accentuated by the palpable, gritty texture of the painting surface. A granular material was mixed with the paint to make the gloomy atmosphere more ominous, the flickering light more lurid and uncertain. Imagine how bland this would look if the surface were flattened and spread thin.

Brushwork as Light and Shade
A ragged brush was used for the raw,
crude smears and jabs of tone that evoke
the mood of a poor woman, ill and dis-
pirited. The expressive light is created by
the manner in which the tone was applied.

Light Against Dark
In this drawing of a fallen bull, the light
comes from the contrast of the white
brush line against the impulsively
brushed-in, black background. There is
no "normal" pattern to the light. The lines
of the brush are improvised and spon-
taneous, as is the movement of the light.

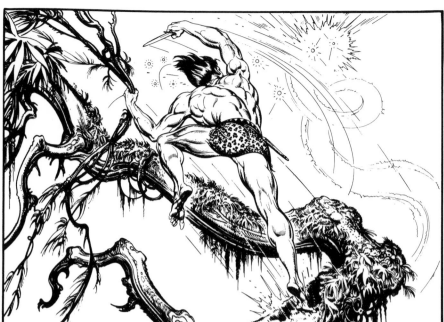

Hallucinatory Light
The feverish jungle lord sees a hallucinatory demon, whose coiled form is represented by light, rendered with halations and linear strokes. The small, glittering suns represent glare spots before the man's feverish eyes. And the movement of the lurching body is indicated with speed strokes that are like lines of light.

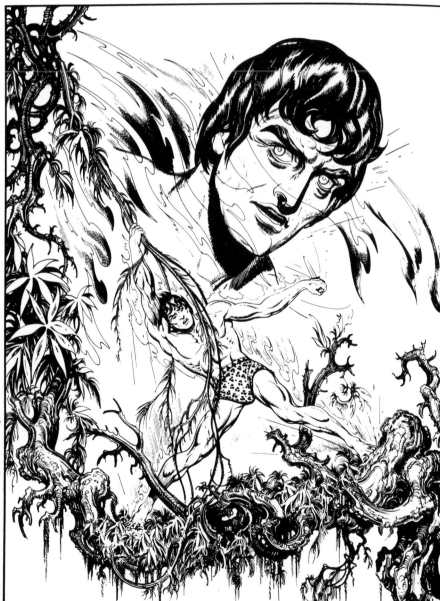

Inferential Light
The jungle man is afflicted with a nightmare brought on by a raging fever, symbolized by the flames that issue from the body and through the enlarged, feverish head with its contracted pupils. The light expresses the body heat.

In this romantic evocation of an Italian
Renaissance prince, the decorative pattern
of light and dark conveys elegance, ex-
travagance, and ostentatious wealth.
Everything sparkles with jeweled detail,
decorative emblazonment, precise chas-
ing, delicate needlework and beadwork,
lavish filigree and embossing. The decora-
tive pattern of the drawing infers a crisp,
clear light that lets us see every detail
close at hand.

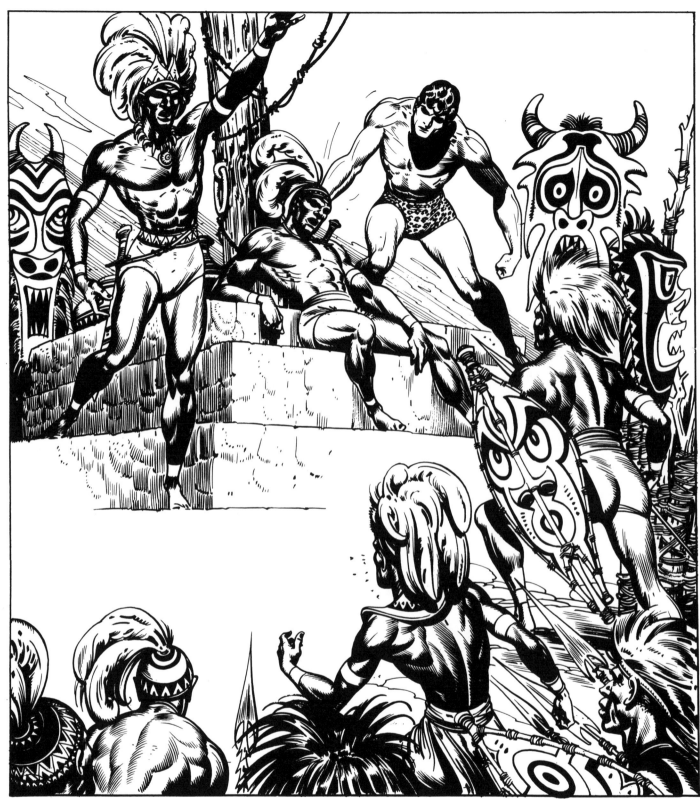

Light as Pictorial Design
Here the organization of lights and darks
controls the design flow of the picture.
The pattern of light and shadow follows a
curving track like a reverse letter C that
curves around from the top left, to the
right, and then swings left again at the bot-
tom of the picture. As shown here, such a
track should be simple and direct.

Light and Dark Create Visual Flow
The lights and darks in this drawing create a visual flow pattern like a spiral nebula. The motif begins with the crossed arms of the central figure—the top arm moving left and the bottom arm thrusting right. From here, the direction of the lights and darks becomes a sweeping, counterclockwise, circular flow pattern.

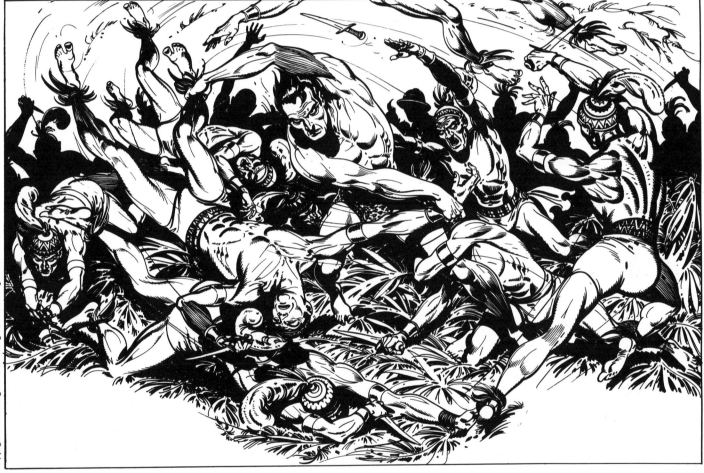

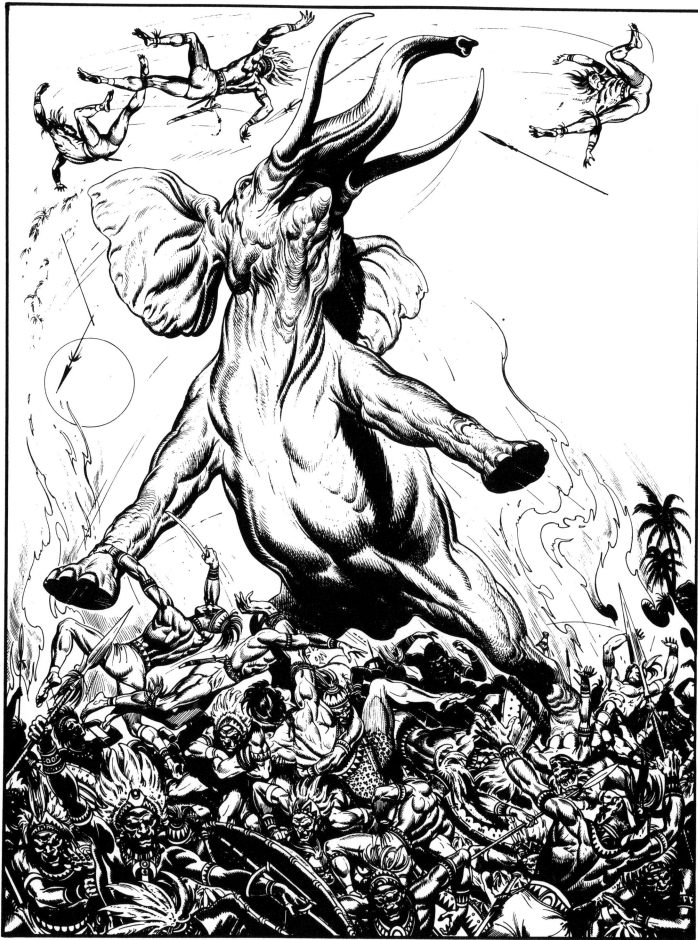

EPILOGUE

I began *Dynamic Light and Shade* with confidence that I would easily cover the material at hand. But as time went on, the territory broadened, and new possibilities emerged that became more varied and complex. I found that the subject of light and shade could involve the entire gamut of art, for whenever form is revealed, it must be defined by some kind of light. Hence, this book barely scratches the surface of this fascinating phenomenon.

I hope you will regard *Dynamic Light and Shade* as a beginning—a preliminary glimpse of a vast, unexplored continent—and that you will be inspired to probe deeper into your own work, finding new insights that will open the boundaries to new solutions of these intriguing problems.

Geometric Light and Shade Pattern
The design pattern of the lights and darks is a very large triangular motif that is built into the elephant's body, and dominates the entire picture. Follow the dark elements, beginning with the head and moving down the outstretched legs. Like the previous two designs, the concept is bold and simple.

SUGGESTED READING

Austen, John. *Shakespeare's Hamlet*. London: Selwyn and Blount, Ltd. (no date).

Ayensu, Edward S., Editor. *Jungles*. New York/Washington, D.C.: Crown Publishers, Inc. and Smithsonian Institution, 1980.

Bayros, Marquis Von. *The Amorous Drawings of The Marquis Von Bayros*. New York: The Cythera Press, 1968.

Bertieri, Claudio. *Graphicar*. Milan, Italy: Fiat, 1976.

Bindman, David. *European Sculpture from Bernini to Rodin*. London: Studio Vista Limited and New York: E.P. Dutton and Co., 1970.

Bittner, Herbert. *Kaethe Kollwitz Drawing*. New York and London: Thomas Yoseloff, Publisher, 1963.

Blaustein, John, and Edward Abbey. *The Hidden Canyon*. New York: Penguin Books, 1977.

Boatner, Charles K., director. *Man . . . An Endangered Species?* Conservation Yearbook No. 4. Washington, D.C.: Department of the Interior, 1968.

Bouma, P. J. *Physical Aspects of Color*. Eindhoven, Netherlands: N. V. Philips Gloeilampen Farbriken, 1947.

Brander, Bruce. *The River Nile*. Washington, D.C.: National Geographic Society, 1966.

Breeden, Robert L., ed. *Nomads of the World*. Washington, D.C.: National Geographic Society, 1971.

Brown, Dale, and editors of Time-Life Books. *The World of Velasquez*. New York: Time-Life Books, 1969.

Campbell, Gordon, and Jim Ivey. *Roy Crane's Wash Tubbs*. New York: Luna Press, 1974.

Cook, Olive, and Edwin Smith. *English Cottages and Farmhouses*. New York: The Studio Publications, Inc., with Thomas Y. Crowell Company, 1955.

Doré, Gustave. *The Doré Bible Gallery*. Philadelphia: Herny Altemus (no date).

Driskell, David C. *Two Centuries of Black American Art*. New York: Alfred A. Knopf and the Los Angeles County Museum of Art, 1976.

Dunham, Barrows. *The Artist in Society*. New York: Marzani and Munsell, Inc., 1960.

Eliot, Alexander. *Three Hundred Years of American Paintings*. New York: Time Inc., 1957.

Feininger, Andreas. *Trees*. Penguin Books, 1968.

Ferris, Hugh. *The Metropolis of Tomorrow*. New York: Ives Washburn, 1929.

Flexner, James Thomas. *American Painting*. New York: Pocket Books, Inc., 1950.

Forrestal, James, Introduction. *U.S. Navy War Photographs*. Washington, D.C.: Department of the Navy, 1945.

Fowles, John. *Islands*. Boston/Toronto: Little Brown and Co., 1978.

Frenzel, Prof. H. K., ed. *Ludwig Hohlwein*. Berlin: Phoenix Illustrationsdruck und Verlag, GMBH., 1926.

Friedlaender, Max J. *On Art and Connoisseurship*. Boston, Beacon Press, 1960.

Gallant, Roy A. *Our Universe*. Washington, D.C.: National Geographic Society, 1980.

Goethe, Johann Wolfgang von. *Theory of Colors*. Cambridge, Massachusetts: M.I.T. Press, 1970.

Grosser, Maurice. *The Painter's Eye*. New York: Mentor Books, 1956.

Guptill, Arthur L. *Drawing with Pen and Ink*. New York: The Pencil Points Press, Inc., 1928.

Haftmann, Werner. *Painting in the Twentieth Century*. New York: Frederick A. Praeger, 1961.

Hawthorne, Charles W. *Hawthorne on Painting*. New York: Dover Publications, Inc., 1938.

Henri, Robert. *The Art Spirit*. Philadelphia: J.B. Lippincott Company, 1960.

Hess, Thomas B., and John Ashbery, ed. *Avant Garde Art*. London: Collier-Macmillan, Ltd., 1967.

Himmel, Paul, and Terry, Watler. *Ballet in Aciton*. New York: G.P. Putnam's Sons, 1954.

Hirsh, Diana, and editors of Time-Life Books. *The World of Turner*. New York: Time-Life Books, 1969.

Holme, Charles, ed. *Sketching Grounds*. London/Paris/New York: The Studio, 1909.

Horswell, Jane. *Bronze Sculpture of "Les Animaliers."* Suffolk, England: The Antique Collectors Club/Baron Publishing, 1971.

Jaques, Florence Page and Francis Lee. *Snowshoe Country*. Minneapolis: University of Minnesota Press, 1944.

Koningsberger, Hans, and editors of

Time-Life Books. *The World of Vermeer*. New York: Time-Life Books, 1967.

Kostelantetz, Richard, ed. *The New American Arts*. New York: Collier Books, 1965.

Krenkel, Roy G. *Cities and Scenes from the Ancient World*. Philadelphia: Owlswick Press, 1974.

Langui, Emile (Introduction). *50 Years of Modern Art*. New York: Frederick A. Praeger, 1959.

Latouche, John, and Andre Cauvin. *Congo*. U.S.A.: Willow, White and Co., 1945.

Levey, Michael. *A Concise History of Painting*. New York: Frederick A. Praeger, Publishers, 1962.

Lorentz, Pare. *The River*. New York: Stackpole Sons, 1938.

Lucie-Smith, Edward, and Celestine Dars. *Work and Struggle: The Painters as Witness*. New York/London: Paddington Press, Ltd., 1977.

Luckiesh, M. *Color and Its Applications*. New York: D. Van Nostrand Company, 1915.

———*Visual Illusions*. New York: Dover Publications, Inc., 1965.

Lundh, Gunnar. *Midsummer in Sweden*. Sweden: LTs Forlag, 1963.

Marshall, Gen. George C., Introduction. *Our Army at War*. New York: Harper and Brothers, 1944.

Mathey, François. *The Impressionists*. New York: Frederick A. Praeger, 1961.

Minnaert, M. *Light and Colour*. New York: Dover Publications, Inc., 1954.

Mitchell, Carleton. *Isles of the Caribbees*. Washington, D.C.: National Geographic Society, 1966.

Muller, Joseph-Emile. *Klee Magic Squares*. New York: Tudor Publishing Co., 1957.

———. *Modern Painting: Expressionists to Surrealists*. New York: Tudor Publishing Co., 1965.

Neumeyer, Alfred. *The Search for Meaning in Modern Art*. Englewood Cliffs, N.J.: Prentice-Hall, Inc., 1964.

Novak, Barbara. "The Meteorlogical Vision: Clouds," *Art in America*, No. 2, February, 1980.

Pivar, Stuart, *The Barye Bronzes*. Suffolk, England: Baron Publishing, 1974.

Pitz, Henry, C. *Pen, Brush and Ink*. New York: Watson-Guptill Publications, 1949.

Poe, Edgar Allen, and Harry Clarke. *Tales*

INDEX

of Mystery and Imagination. New York; Tudor Publishing Co., 1939.

Prideaux, Tom, and editors of Time-Life Books. *The World of Delacroix.* New York: Time-Life Books, 1966.

Richardson, E.P. *A Short History of Painting in America.* New York: Thomas Y. Crowell Company, 1963.

Ritchie, Andrew Carnduff. *Masters of British Painting, 1800–1950.* New York: The Museum of Modern Art, 1956.

Robert, Ainslie, and Charles P. Mountford. *The Dreamtime Book.* Englewood Cliffs, N.J.: Prentice-Hall, Inc., 1973.

Rudd, Clayton, ed. "Canyonland," *Naturalist,* vol. 21, no. 2, Special Issue. Minneapolis: Natural History Society, 1970.

Schreider, Helen and Frank Schreider. *Exploring the Amazon.* Washington, D.C.: National Geographic Society, 1970.

Schultz, Guenther. *Under Sail Round Cape Horn.* New York: Dodd, Mead and Company, 1954.

Simon, Howard. *500 Years of Art in Illustration.* New York: Garden City Publishing Co., Inc., 1949.

Symons, Arthur. *The Art of Aubrey Beardsley.* New York: Boni and Liveright, Inc., 1918.

Sypher, Wylie, ed. *Art History: An Anthology of Modern Criticism.* New York: Vintage Books, 1963.

Thiessing, Frank C., ed. *Ernie.* St. Gall, Switzerland: Zollikofer and Co., 1948.

Traeger, Jorg. *Caspar David Friedrich.* Munich: F. Bruckmann KG Verlag, 1976.

U.S. Department of the Interior. *Our Living Land,* vol. 7, Conservation Yearbook Series, 1971.

Wallace, Robert, and editors of Time-Life Books. *The World of Rembrandt.* New York: Time-Life Books, 1968.

Walker, Jearl, Introduction. *The Physics of Everyday Phenomena.* San Francisco: W.H. Freeman and Co., 1979.

Wertenbaker, Lael, and editors of Time-Life Books. *The World of Picasso.* New York: Time-Life Books, 1967.

Wolf, Thomas H. *The Magic of Color.* New York: Odyssey Press, 1964.